KILMARNOCK
THROUGH TIME
Frank Beattie

AMBERLEY PUBLISHING

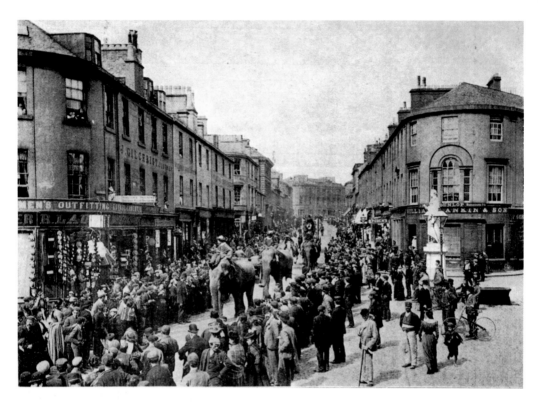

On Parade
One of the photographs that did not quite make it to the final book ... Elephants on parade in Portland Street in 1898.

First published 2012

Amberley Publishing
The Hill, Stroud
Gloucestershire, GL5 4EP

www.amberley-books.com

Copyright © Frank Beattie, 2012

The right of Frank Beattie to be identified as the Author of this work has been asserted in accordance with the Copyrights, Designs and Patents Act 1988.

ISBN 978 1 84868 410 2

British Library Cataloguing in Publication Data.
A catalogue record for this book is available from the British Library.

Typeset in 9.5pt on 12pt Celeste.
Typesetting by Amberley Publishing.
Printed in the UK.

Introduction

In presenting this latest collection of Kilmarnock pictures, I have tried to concentrate on images that are not so well known, while still wishing to tell the story of the town and people. The story, however is not complete. History never finishes.

As this book was being completed the construction of two new schools is nearing completion and work on another is about to start. Our new athletics stadium, built to Olympic standard, is about to be opened and construction work is almost complete on a prominent site in John Finnie Street that has been derelict since 1989.

From the initial selection, not all the pictures and not all the topics made it to the final cut ... so apologies to the guys in local success stories: Biffy Clyro; television presenter Kirsty Wark; Iain Lauchlan, who created the Tweenies; and to Colin Mochrie, actor, perhaps best known for his appearances on *Who's Line is it Anyway?* Maybe next time...

For the use of photographs I must thank the staff at the Burns Monument Centre in Kilmarnock and also at East Ayrshire Council's Museums & Galleries department.

Personal thanks for help and the use of photographs go to Mike Bisset, Norman Gee, Robert Logan, Helen McDougall, John McClymont, Derry Martin, Richard Ross, Margaret Urquhart and William Wilson.

Other picture credits go to Hector Macdonald, J. Stewart McLaughlan, Bill Paton and Gordon Robb.

Early Days

Kilmarnock's origins are lost in history. The Romans held a tentative grip on this area. They had a fort at Loudoun Hill and they had harbours on the coast. There is a supposition, though without evidence, that there was a road from Loudoun Hill to Irvine. Another, perhaps, leading from Ayr towards what is now Glasgow. If so, the roads crossed near what is now Kilmarnock.

The name Kilmarnock is supposed to mean 'the Church of St Marnock', or more properly, the church dedicated to the memory of St Marnock. Which came first, the community or the church? Or did they simply develop together? Did they start to grow at that ancient Roman crossroads? If so, the evidence is lost. It is clear that Kilmarnock grew up in the Christian era, sometime after the Romans had packed up and gone home. Some say that 1066, and all that, is a matter of English history. Not so. The Norman invasion had a major impact on Scotland.

Many of Ayrshire's great castles date from Norman and immediate post-Norman times. In 1263 territorial disputes between Scotland and the Vikings came to a head at Largs. The Boyd family, like so many others, immediately helped Scotland's cause in the climactic battle, which saw an end to Norse claims over the Scottish islands. The Boyds were rewarded by the King of Scots with a gift of land in Cunninghame.

Ayrshire is the birthplace of both Wallace and Bruce, who fought for the independence of Scotland, not from the Vikings, but England's Edward I. In the summer of 1314 Bruce led his troops at Bannockburn, where King Edward was sent 'homeward to think again'. Robert Boyd was in control of the right flank of the Scottish army and was rewarded with more lands in the Kilmarnock area. Kilmarnock in the fourteenth century probably consisted of the church, a few homes clustered nearby and not much else.

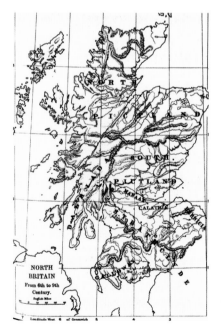

Emerging Nation
This map was published in the 1890s but represents the Scotland of the sixth to the ninth centuries. The area that was to include what is now Ayrshire was Strathclyde. No Ayrshire towns are marked on this map but they did exist, particularly on the coast. There were some small scattered communities in the area now occupied by the urban sprawl of Kilmarnock.

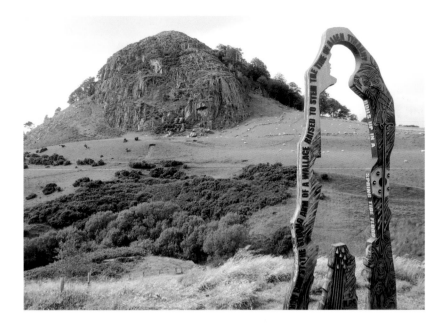

Beacon Hill

In the days before roads or maps, travellers had to make use of outstanding natural features. When the Romans came to southern Scotland they built a fort at Loudoun Hill. Later this easily found feature was the site of actions in Scotland's wars of independence and both Wallace and Bruce inflicted defeats on the Auld Enemy here. Today the *Spirit of Scotland* sculpture is an attraction. The hill is said to have been used as a beacon hill in those far off days.

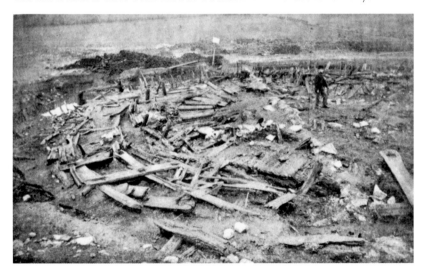

Crannog Capers

From about the start of the Christian era until around AD 525, people lived in the crannog at Buiston near Kilmaurs. Nineteenth- and twentieth-century investigations found a wide variety of artefacts there. Crannogs were secure lake dwellings, constructed by building a circle of strong wooden stakes in shallow water, filling it in with earth and stones, then building on it.

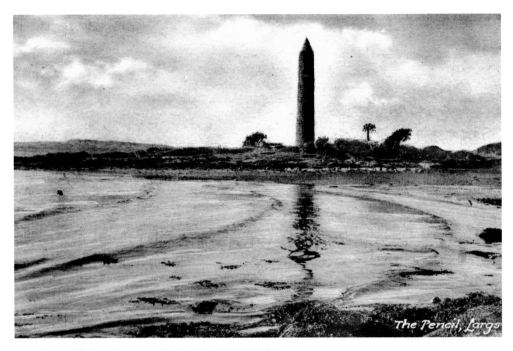

The Pencil, Largs

CONFIDO

GOLD BERRY

KILMARNOCK.

Drawing a Line

In the middle of the thirteenth century, King Haco of Norway was worried about the increasing restlessness in the western fringes of what he considered to be his domain. In 1263 he gathered a huge fleet off the east coast of Arran and set sail for Largs. But the day was won by the Scots under Alexander III and the defeat saw a sharp decline in Norse interest in dominating western Scotland. The tall slender battle monument is known as The Pencil.

Loyalty Rewarded

As a reward for loyal support at Largs, Alexander III, King of Scots gave Robert Boyd substantial areas of land in Cunninghame. At the engagement, Boyd had been involved in fighting at Goldberry Hill. Goldberry, sometimes Gold Berry, was adopted as the family motto. The squirrels represent industry and thrift and the two fingers are raised in the sign of the benediction.

Troubled Times

Even with no Viking threat, Scotland was still not secure. Our troublesome neighbour looked on our land with envious eyes and slowly and surely drew their plans against us. With many of the country's potential leaders murdered, William Wallace, born at Ellerslie in Riccarton parish, emerged as a national hero who forged the people into an effective resistance force. After his murder, Bruce led the nation to victory at Bannockburn.

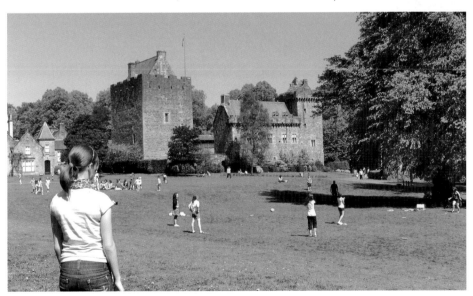

A Nation Again

Bruce led Scotland to victory and independence at Bannockburn in 1314. Again, loyalty came from the Boyds and as a reward the family was given more land in Cunninghame. It is by no means clear if a structure at the site of the present Dean Castle existed at this time. But in time the Boyds built the keep and the palace at Dean and occupied it for more than four centuries.

Mystery Man

The date on the Soulis Monument in Kilmarnock is 1444 but this is about 100 years out. It seems that, having failed to support Scotland's cause in the war of independence, land belonging to Soulis was taken from him and given to the Boyds. But just why a monument was erected, apparently to honour Soulis, has been forgotten.

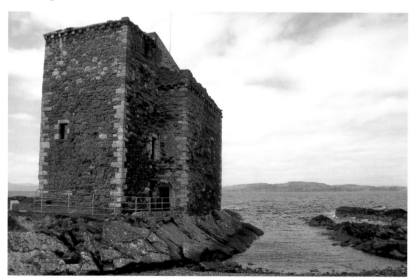

Castle by the Sea

Portencross Castle, near West Kilbride, was originally called Ardneil Castle and was owned by the Ross family, Sheriffs of Ayr. However, in the troubled time of the war for independence the Ross family supported Balliol as King of Scots, rather than Bruce. When Bruce became King of Scots, the castle was presented to the Boyds, the same family who would later have a long association with Dean Castle in Kilmarnock.

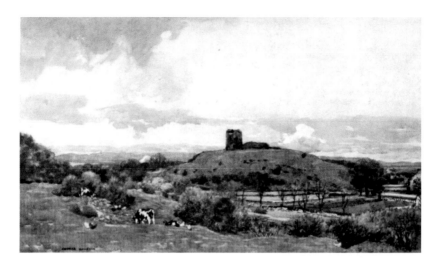

Dundonald Castle

Archaeological evidence suggests the site of Dundonald Castle has been occupied for over 4,000 years. A settlement became a fort, which became a castle which, having been replaced by a newer and stronger one, became a royal residence. It was here that Robert II, King of Scots, held court. He died here in 1390. Robert III died here in 1406. The castle was allowed to fall into ruin but now, in the hands of Historic Scotland, it has been partially restored and is open to the public.

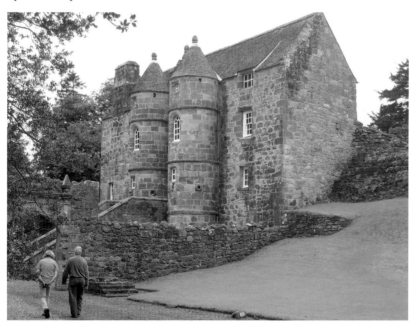

Rowallan Castle

The earliest part of old Rowallan Castle dates from the thirteenth century and was occupied until the first decade of the twentieth century when it was replaced by New Rowallan. Elizabeth Mure, 1316–90, was born at Rowallan. She became the wife of Robert II, King of Scots, in 1349.

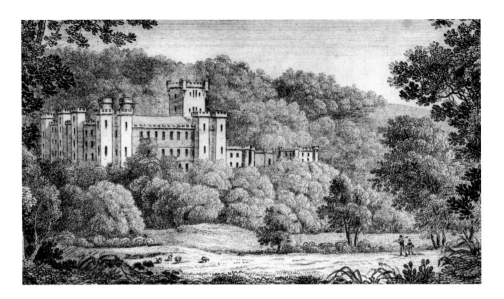

Loudoun Castle

For six centuries Loudoun Castle was home to the Campbell family and the mother of Scotland's hero, William Wallace, was born here. As the Campbell family grew in importance the castle was extended. In later years it was known as the Windsor of the North. Loudoun Castle was destroyed by fire in 1941 and today only a shell of the once great building survives.

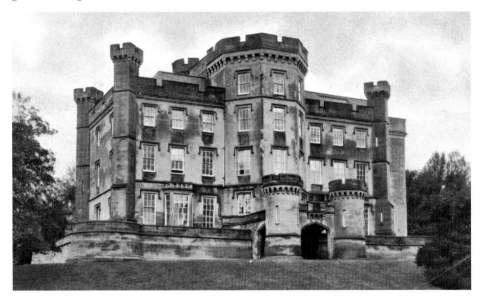

Caprington Castle

Caprington Castle sits on the southern edge of Kilmarnock. As with so many others, the castle's very early history is lost; but it is mentioned in a charter dated 1385. At one time the property belonged to the Wallace family but as early as 1462 it belonged to the Cunninghame family who still possess it today. Many alterations to the building have been made over the centuries and the façade of the castle seen today is the work of architect Patrick Wilson who reconstructed Caprington Castle in 1829.

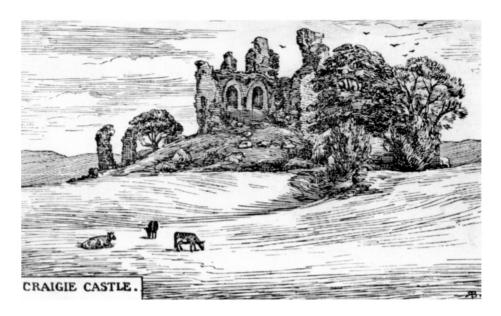

CRAIGIE CASTLE.

Craigie Castle

At an early period, Craigie Castle was the most magnificent castle in Ayrshire. It belonged to the Lyndesay family and passed to the Wallaces of Riccarton through marriage. The Wallaces occupied Craigie until they moved to Newton-upon-Ayr around 1600, leaving their once-magnificent castle to fall into ruin.

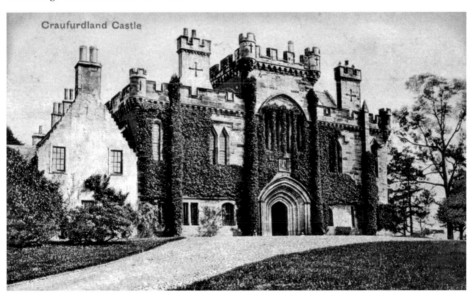

Craufurdland Castle

Craufurdland Castle

The Craufurds of Craufurdland have occupied the castle since the start of the thirteenth century. Craufurdland has been extended and altered at various times. The present structure shows three distinct phases of construction. The section to the left in this photograph dates from 1648 and the section to the right was built in the fifteenth or sixteenth century, possibly on the site of an earlier structure. The main part of the front with its gothic entrance was built in 1825.

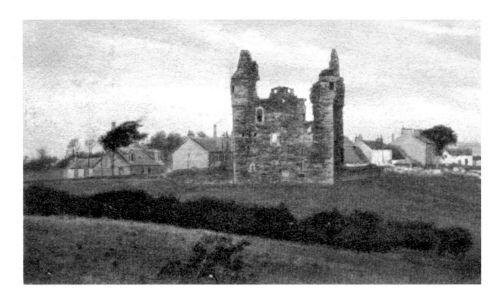

Busbie Castle

Like so many other castles in the area, the earliest part of Busbie Castle at Knockentiber was built at the end of the fourteenth century. It was substantially extended in the sixteenth century. Nothing of Busbie Castle remains today. The last remnant was demolished in 1952 because of fears that the ruin was unstable.

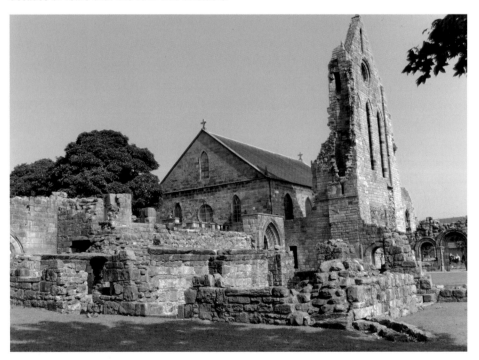

Dawn of Christianity

The date of the founding of Kilwinning Abbey is not known, but it is generally thought to be in the twelfth century. The monks were responsible for the whole of Cunninghame and that included Kilmarnock.

The Kirk (Right)

As with so much of Scotland's medieval history, the origin of the Laigh Kirk has been lost. A church was probably founded here in the twelfth or thirteenth century. It has been extended and rebuilt on various occasions and has undergone some changes of name. Today it is the New Laigh Kirk. The present building was constructed in 1802, though the base of the tower has a 1440 date stone.

New Kirk (Below)

The Old High Kirk dates from 1731, having been built as a new kirk to accommodate a growing population. The architecture is plain and the tower is a later addition. In the kirkyard there are stones to John Wilson who printed the first edition of Burns' poetry and established Ayrshire's first newspaper; Thomas Kennedy, founder of Glenfield and Kennedy; Thomas Morton, inventor, industrialist and amateur astronomer; and John and William Tannock, artists. Restoration treatment at the church building was completed in 2007.

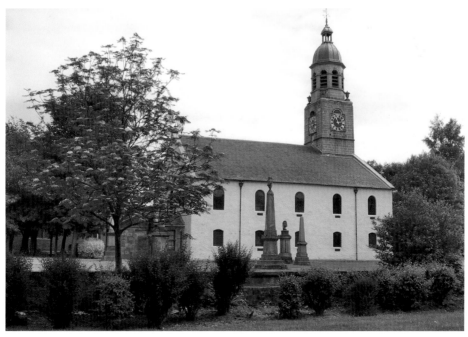

Growth of the Town

The earliest references to Kilmarnock are vague about the size of the community. It may have been little more than a cluster of dwellings around the church. In the area around what was called Kilmarnock there were farms and other clusters of homes, with names that are now familiar as areas of the town. To the south of Kilmarnock, half way to Riccarton, there was the Netherton. To the north, even before you reached the Dean Castle, there was a row of cottages called Beansburn.

As the town grew, these and various farms and estates were absorbed into the urban sprawl of Kilmarnock. Riccarton, once a separate parish, was absorbed into Kilmarnock. Between 1811 and 1851 the population of Kilmarnock doubled, but the town did not grow in proportion. On the whole most new building work was on gap sites, but construction of houses at Robertson Place by the Kilmarnock Building Company was one of the exceptions.

There was considerable growth in the size of the town during the second half of the nineteenth century. After the First World War, the effort was on to provide homes fit for heroes. Many new streets were added. Big housing schemes began to be built in the years after the Second World War, firstly at Shortlees, then in the 1960s at the Grange and at Bellfield and Onthank.

It was not enough. The late 1960s and early 1970s saw massive house building at New Farm Loch. As people wanted more space for their homes and cars, more land was allocated for house building and many areas on the edge of town saw house-building projects, the biggest of which was at Southcraig and later Dunsmuir Park. Brownfield sites, left by the demise of old heavy industries, were filled with housing. House building stalled in the early years of the twenty-first century but by 2012 there were signs of recovery.

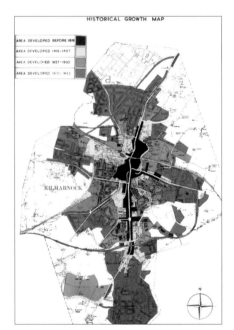

Mapping It Out
This map showing the growth of Kilmarnock was published in a town plan in 1953. Development before 1819, shown in black, is clustered around the church and on the route to Riccarton. As industrialisation took hold over the next fifty years the town expanded in all directions. From this map it is clear that there was huge expansion in the first half of the twentieth century. Since this map was made expansion has continued in all directions with housing areas at Bellfield, Onthank, New Farm Loch, the Grange, Southcraig, Dunsmuir Park and other areas and industrial estates, particularly at Moorfield.

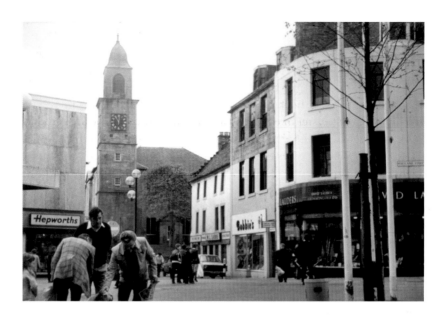

Cheapside

The line of Cheapside, or Cheapside Street, was opened up and built on around 1550 or before. It is likely to have originally been called 'Chapside'. In old Scots, a 'chap' was a shop and 'chapman' a trader, so Cheapside Street, next to or at the side of the Cross, was probably the main place used by market traders. This picture was taken in 1974.

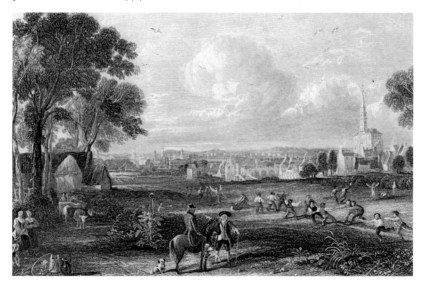

Riccarton

A royal charter of 1165 gave the grant of land in north Kyle to Richard Wallace, the great-grandfather of Scotland's great hero, Sir William Wallace. At the time, the River Irvine marked the boundary between Kyle and Cunninghame. The area of land granted to Richard was named after him but what was originally 'Richard's town' has become 'Riccarton', and Riccarton has become part of the urban sprawl of Kilmarnock.

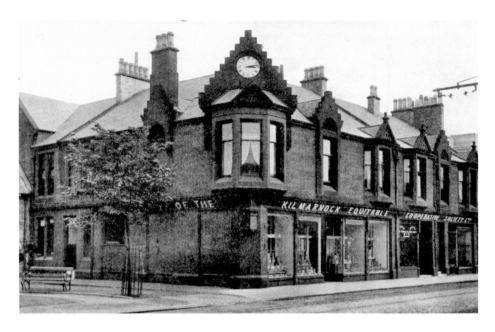

Square Man

In 1765, William Cunninghame, the 13th Earl of Glencairn, had a new and wide route from Kilmarnock to Riccarton opened up. It became Titchfield Street, the Holm Square – now Glencairn Square – and Low and High Glencairn Streets. Before this road was made, the route from Kilmarnock to Riccarton, via the Netherton, was narrow and crooked. The new square quickly became a commercial hub. Above is a photograph from 1909 showing a branch of the Co-op in the south-east corner of the square, and below an old cottage in the south-west corner photographed in 1938 shortly before that corner was cleared.

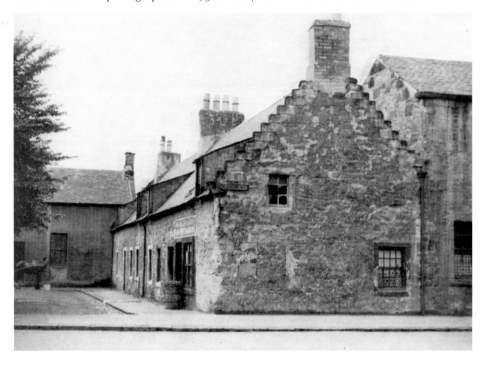

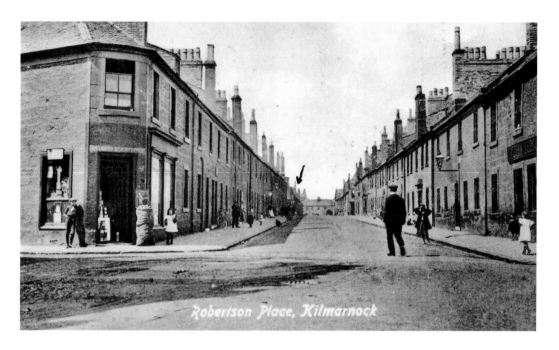

Robertson Place, Kilmarnock

New Growth

In the first half of the nineteenth century, Kilmarnock's population almost doubled, but in the same time few new streets were built. Most new construction was in gap sites. However, in 1824 the Kilmarnock Building Company was formed. Members each paid an entry fee and a monthly subscription to allow the building of houses. They built an entirely new street called Robertson Place, named after James Robertson on whose land it was built.

Transformation

One of the old streets that ran off Glencairn Square was called The Loan. Originally, a loan was an opening between cornfields, used for driving the cattle. Later, The Loan was transformed into West and East Shaw Streets. They were renamed in honour of Sir James Shaw from Riccarton who became an MP and Lord Mayor of London.

Battle Honour

Greenfoot was a narrow lane until it was reshaped into a street in 1752. It was renamed after the Battle of Waterloo, 1815, to commemorate the efforts of many local men who fought in that battle. John Wilson established a printing press here and in 1786 printed the Kilmarnock Edition of the poems of Robert Burns. The illustration is from an early twentieth-century painting by Andrew Law in the care of East Ayrshire Council's Museums & Galleries department.

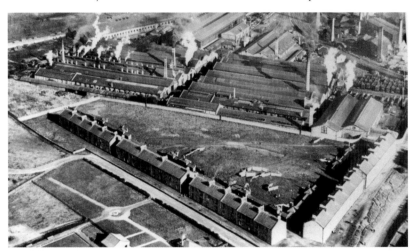

A Square Deal

In 1856 the Glasgow & South Western Railway Company confirmed Kilmarnock as a key railway town when it transferred its workshops from Cook Street in Glasgow to Bonnyton. At about the same time the company began building homes for their workers at Bonnyton Square and other parts of Bonnyton. In 1863 there were twenty-three houses, occupied by ninety-two families. The company ran their own gasworks and their own library. The houses forming Bonnyton Square were demolished in 1966 and 1967, long after the railway company had disappeared.

King Plan

At the start of the nineteenth century the Marquis of Titchfield, later the 4th Duke of Portland, came up with a long-term, four-point plan. At Troon he wanted to build a harbour and a new town; he planned a railway to take coal from Kilmarnock to the harbour and he planned a new wide street to be Kilmarnock's new main place of business. This became King Street, which was opened in 1804.

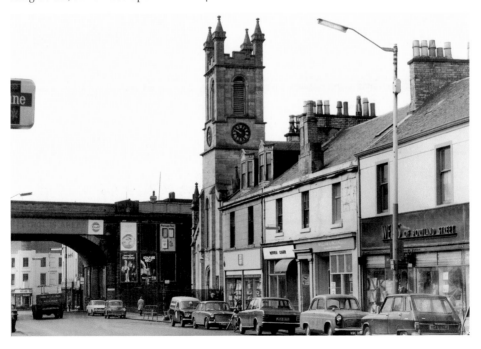

Expanding the Plan

King Street was an immediate success and soon work started on an extension, going north to link the new market cross area with the road to Glasgow. This extension became Portland Street.

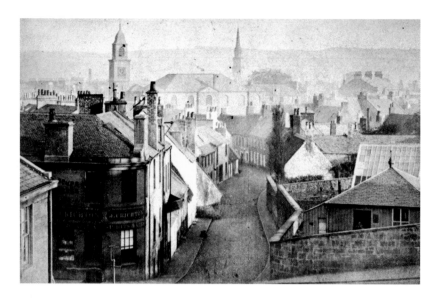

The Strand

The Strand, or Strand Street, ran from Cheapside to the Strandhead Toll and was one of the earliest streets of the town, dating from the 1600s. Around 1700 it was the only important street in Kilmarnock, and in 1708 was the first street in the town to be laid with cobblestones. The street also had drainage in 1726. In the middle of the eighteenth-century houses were small and badly ventilated. In 1864, it was widened and in 1879 the whisky firm Johnnie Walker moved to Strand Street. This picture is probably from the 1870s.

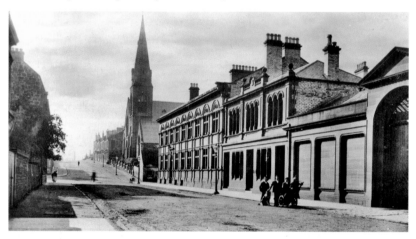

Elegant Architecture

By the second half of the nineteenth century, more attention was given to architectural details such as in Woodstock Street, where mascarons, or sculpted heads, illustrate a wide variety of ethnicity. This street is named after Viscount Woodstock, 1st Earl of Portland. Part of Woodstock Street is sometimes referred to as West Woodstock Street and part is also known as Grange Place. Together they run from John Finnie Street to Fullarton Street. The Woodstock Centre is on the corner with North Hamilton Street, a site formerly occupied by Kilmarnock Academy.

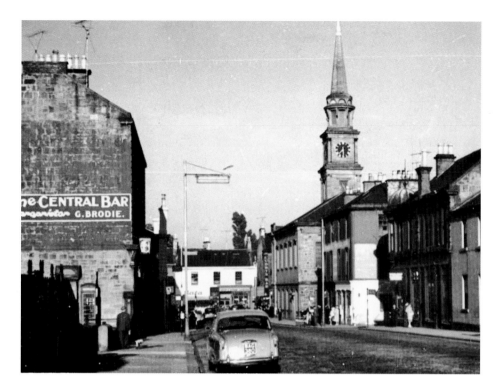

Public Buildings

St Marnock Street began to be developed in the 1830s. Kilmarnock House was in here, though it predated any street. Saint Marnock Street today has several interesting buildings. The office of the procurator fiscal is here as is the area police headquarters, the Sheriff courthouse and St Marnock Street Church, which was built in 1836. This picture is from the 1950s.

Longpark

A 1923 Act of Parliament allowed houses to be built at Scott Road, Fulton's Lane, Townholm and Longpark. Then Acts of 1924 and 1925 allowed construction of more than 900 council houses at Annanhill, Ayr Road, Bonnyton, Craigie Road, Granger Road, London Road, Longpark, New Mill Road, New Street, Stoneyhill Avenue and Yorke Place.

Pre-Fabs

In the years following the Second World War, there was an urgent need for new housing. Manufacturing had changed and houses were mass-produced in factories and constructed onsite. The initial intention was that these pre-fabs would be temporary homes, but some are still around.

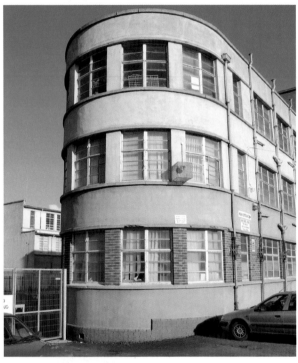

Shortlees

Once the immediate demand for housing had been met with pre-fabs, big schemes of council houses were built. In Kilmarnock Shortlees was the first big post-war scheme, and with the houses came shops, churches and schools. Shortlees School, seen here, was recently replaced by a new building.

Grange Estate

The emphasis on house building continued to be on council-owned housing into the 1960s but there was still a place for the private market. In the early 1960s it was private housing that pushed the boundary of the town's built-up area with the construction of homes in the Grange Estate.

Further Expansion

It was not war but social change that drove the next big expansion. As the 1960s drew to a close people began moving out of crowded tenement buildings and taking houses. At this time the massive New Farm Loch development was being constructed.

Boom Time

The close of the twentieth and start of the twenty-first century was boom time for the house builders. Land around Kilmarnock was snapped up and an unprecedented house-building boom started. This included the massive development at Southcraig and at other places like Dunsmuir Park.

Commerce

The first form of commerce in Kilmarnock was based on what was around the town. Agriculture and the extraction of stone and minerals were important. In the middle of the seventeenth century, metal working was carried on, but this was not yet on an industrial scale. For the people who lived in the various scattered farms and communities, Kilmarnock was the centre and eventually a weekly market was established. Cattle provided milk and other dairy produce. There were several creameries in and around Kilmarnock. The town became well known for cheese making and, in the nineteenth century, some of the country's biggest cheese fairs were held in Kilmarnock. The working of leather was also important and everything, from saddles to boots, was made, though in the early days, there were no machines to help the craftsmen. Wool from local farms was made into clothes, bonnets, blankets and eventually carpets. Stone was quarried and so was clay. Coal was mined and as well as being used locally, there was enough left over to export.

Before the Industrial Revolution many towns like Kilmarnock could be fairly self-sufficient. They had to be, because the transport system in the country wasn't up to much. Even so, there was a good export trade and before the start of the nineteenth century produce was exported from Kilmarnock through the port at Irvine. Most business concerns were family run and skills were passed from father to son. Manufacturing was at cottage craft level, even the ones that relied on imported goods.

In 1770 Kilmarnock weavers started working on silk for the first time. This industry grew rapidly and became an important part of the Kilmarnock economy. There were soon 240 looms used for silk, but still no big factories. But these cottage crafts – wool, leather, coal and stone – laid the foundation for some major new industries. All they needed was the Industrial Revolution.

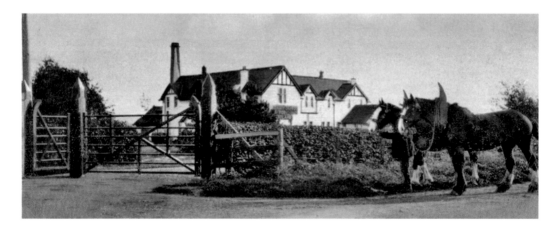

Dairy Lessons
Kilmarnock was not just an industrial hub, but a centre for dairy farming. In 1889 the Scottish Dairy Institute was formed when various dairy associations in the south west of Scotland were amalgamated. The institute immediately set about turning part of Holmes Farm into an agricultural school. It later became the Dairy School for Scotland.

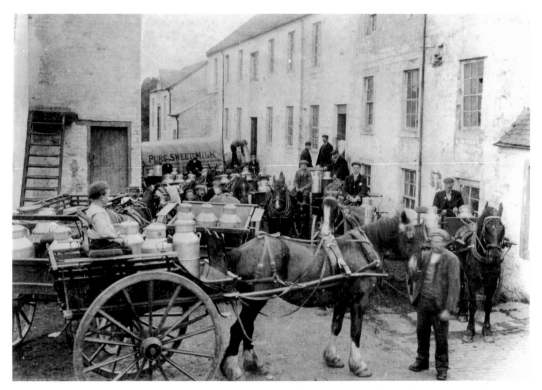

Milking It

Milk, cheese and other dairy products came out of large creameries such as this one at Waterside. At the close of the nineteenth century, Kilmarnock hosted some of the biggest cheese fairs in the country.

Cream of the Business

One of the biggest, and certainly the best known, of the local creameries was Rowallan Creamery. It was established at Kilmarnock in 1886 by John Wallace as a 'butterine' factory – the first such business in the area. It later produced leading brands such as Banquet Margarine. The factory closed in 2002.

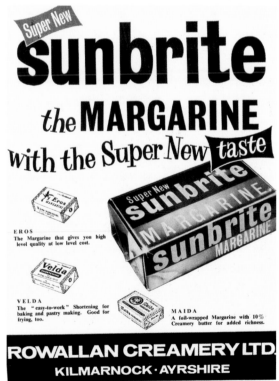

Super New **sunbrite** the **MARGARINE** with the Super New taste

EROS
The Margarine that gives you high level quality at low level cost.

VELDA
The "easy-to-work" Shortening for baking and pastry making. Good for frying, too.

MAIDA
A foil-wrapped Margarine with 10% Creamery butter for added richness.

ROWALLAN CREAMERY LTD.
KILMARNOCK · AYRSHIRE

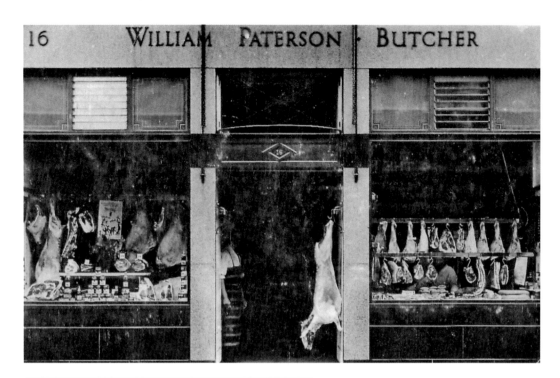

WILLIAM PATERSON · BUTCHER

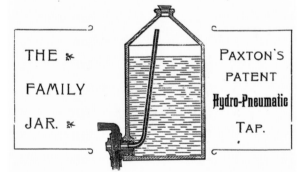

Beer at Brewers' Prices.

THE ✳ FAMILY JAR. ✳

PAXTON'S PATENT Hydro-Pneumatic TAP.

SPECIALLY ADAPTED FOR HOUSEHOLD USE.

ALES KEEP BRISK ON DRAUGHT no matter how long the Jar remains only part full.

No VENT PEG REQUIRED. Our Patent Hydro-pneumatic Tap, being complete in itself, and automatic in action, will draw total contents from vessel without the aid of venthole or any opening other than itself. It is strongly made, and cannot easily get out of order.

Turn the Tap till the Liquor flows, and NO FURTHER.

PRICES—Family Jars about five gallons :

INDIAN PALE ALE,	7s 6d.
XXX STOUT,	7s 6d.
SWEET ALE,	8s 0d.

No charge is made for use of Jar and Tap for six weeks, if kept longer 6d per week will be charged.
NUMEROUS TESTIMONIALS ON APPLICATION.

George Paxton & Sons,

I.P. ALE, SWEET ALE AND STOUT.

Brewers and Maisters, Richardland Brewery. Kilmarnock.
ESTABLISHED 1803.

Also, Commercial Inn, Riccarton, and Klondyke Bar, Market Lane.

Butcher Shop

There were many butchers' shops in the town. William Paterson established his butcher's shop in 1835. In those days they were called fleshers. His business lasted more than 100 years. This picture dates from the time of the First World War. Note that carcasses are uncovered. What would the Food Standards Agency say about that today?

Cask Ale

Before 'beer' was mass-produced in factories the making of ales was a craft passed on from one generation to the next and most towns had their own breweries. George Paxton's brewery was founded in 1803 and lasted more than 100 years. One member of the family even invented and patented a device which allowed customers to take home a mini-cask to ensure the quality of the ale.

Groceries

Until the advent of the big supermarkets, each town and community had many grocery shops. In Kilmarnock D. H. Hannah's grocery shop was established in 1926 and traded until 2008. It was very much a traditional grocery shop with fine products and friendly banter from the proprietors.

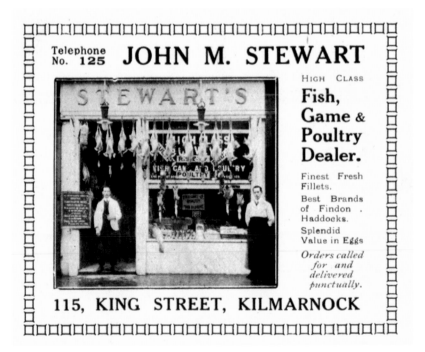

Telephone No. 125 **JOHN M. STEWART**

High Class **Fish, Game & Poultry Dealer.**

Finest Fresh Fillets.

Best Brands of Findon Haddocks.

Splendid Value in Eggs

Orders called for and delivered punctually.

115, KING STREET, KILMARNOCK

Something Fishy

As with the grocery and butchers' shops, there were many fish and poultry shops. This advert from the 1920s is typical. In general fish was caught and landed locally and most of the poultry and game came from local sources.

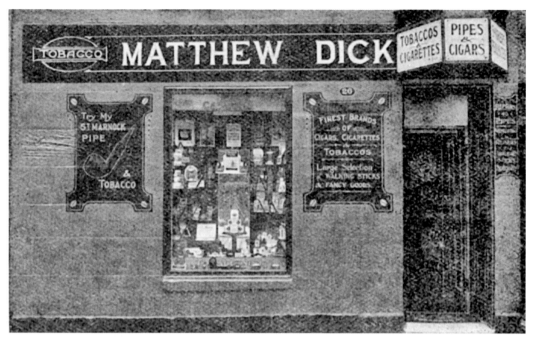

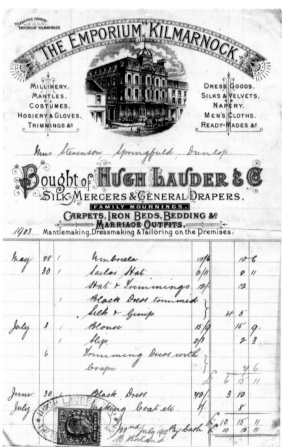

Up In Smoke

There were many tobacco dealers until fairly recently. Many were small, family-run businesses and the tobacconist would mix a variety of products for customers. Many shops also made their own pipes and, for some reason, walking sticks.

Bigger Shops

As commerce grew so did the local shops. Not only did they get bigger, but they started selling a wide variety of goods. Some took on grand descriptions like 'emporium'. Lauder's was founded in 1864 in King Street. There was a devastating fire in 1923, after which a new building known as Lauder's Emporium was built. It later became part of the House of Fraser and later still the property was split into three different units.

Food For Thought

Another branch of the Lauder family started a bakery in 1869. It lasted more than 100 years. The Lauders had their own tearoom and produced a wide variety of products such as traditional Scottish shortbread, which was sold in decorated tins.

Big Bakery

The Co-op took advantage of economy of scale and, as with many branches in Kilmarnock and other Ayrshire towns, the Kilmarnock Co-op established a large central bakery in St Andrew Street. This picture was taken there in 1909.

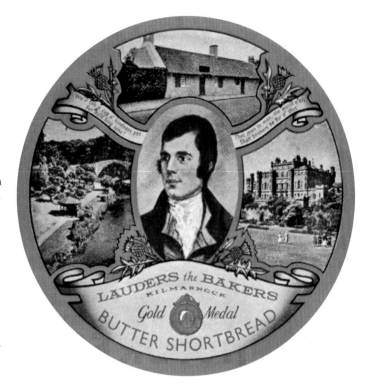

LAUDERS the BAKERS
KILMARNOCK
Gold Medal
BUTTER SHORTBREAD

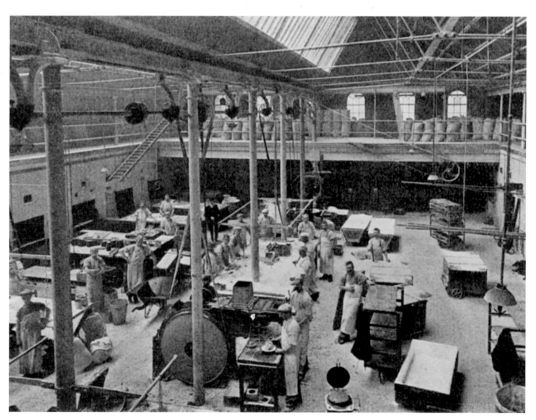

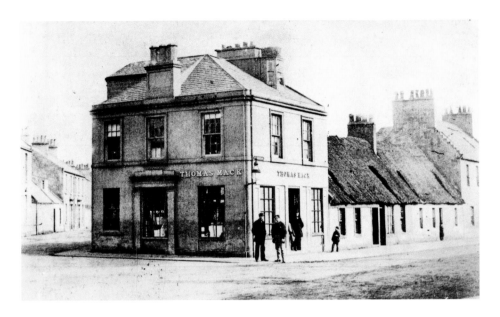

Mack's Corner
Corner sites were always at a premium. This late nineteenth-century picture shows Thomas Mack's drapery shop which faced onto Fowlds Street. The street on the right with the thatched buildings is Titchfield Street and the one on the left is St Andrew Street.

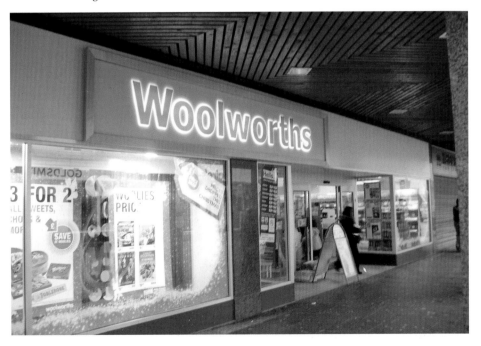

The Big Players
Inevitably some retailers that started as small concerns began to open branches outside their home territory and soon became national fixtures in the high streets of most towns. F. W. Woolworth opened a 3*d* and 6*d* shop at the corner of King Street and Market Lane in Kilmarnock in 1929. It was a shock when the national chain closed in 2009.

Showing the Light

Away from the retail trades, there were many other small businesses which provided a wide variety of services. Typical of them was Adam Caldow, a plumber and heating engineer who also manufactured lamps, along with something he described as improved self-acting hydro-pneumatic beer-raising apparatus.

Cleaned Up

An American Steam Laundry was established in Kilmarnock in 1891 and quickly earned a good reputation for an efficient service. This picture from about 1930 shows Jimmy Hood with his Steam Laundry lorry. Jimmy was a POW during the First World War. (Picture from Helen McDougall, Moscow)

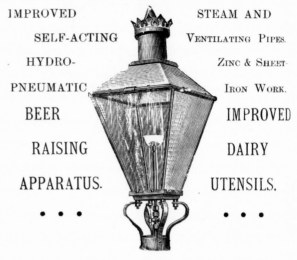

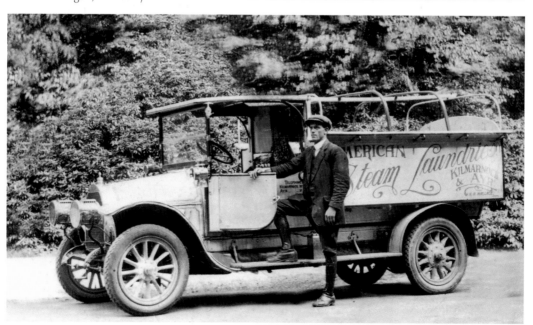

31

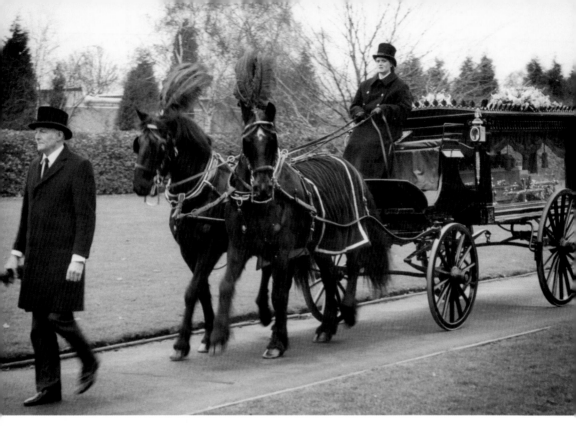

Coach Man

John Peden established a coach-building firm in Kilmarnock in 1826. It became something of an institution and lasted into the twentieth century. The main picture shows a Peden funeral coach which is still in use in Kent, England.

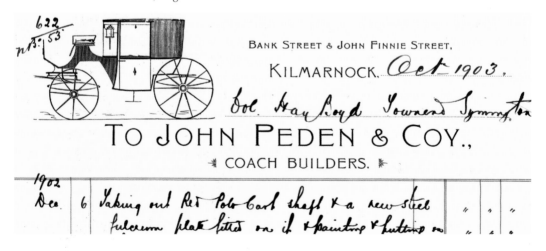

622
n°B.° 53

BANK STREET & JOHN FINNIE STREET,

KILMARNOCK. *Oct 1903,*

Sol. Hay Boyd Townend Symington

TO JOHN PEDEN & COY.,
✳ COACH BUILDERS. ✳

1902
Dec. 6 Taking out Red Polo Cart shaft & a new steel fulcrum plate fitted on it & painting & putting on

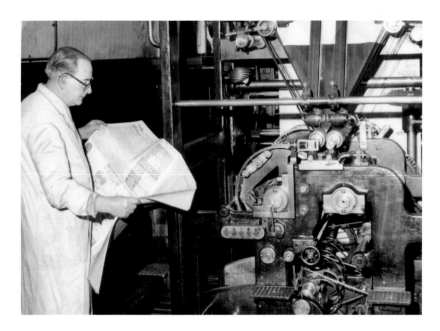

Hot Off the Press

Ayrshire's first weekly newspaper was the *Ayr Advertiser*, established by Kilmarnock man, John Wilson, and his brother, Peter, in 1803. Others soon followed. The *Kilmarnock Standard* was founded in 1863 and today serves the Kilmarnock area with a weekly printed newspaper as well as online news and features. This 1963 picture shows the special centenary edition coming off the press.

Bank On It

In 1710 the gently sloping ground of Kirkhaugh was built up to make it level and therefore suitable to build shops and houses on. The land here had previously been part of the graveyard of the parish kirk, now the New Laigh Kirk. The new street was called Bank Street, being on the edge of the Kilmarnock Water. It quickly became a commercial street and still is today.

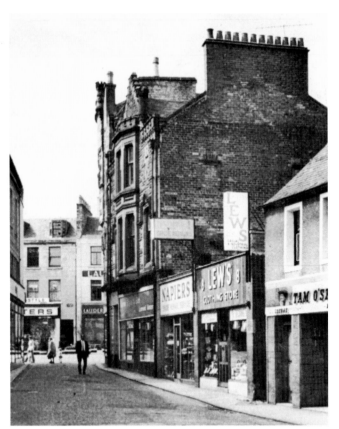

Battle Honour

Waterloo Street was a narrow lane until it was reshaped into a street in 1752. Originally it was called Greenfoot, renamed after the battle of Waterloo in 1815 to commemorate the efforts of many local men who fought in the battle. It was a commercial hub, but was demolished in the 1970s and replaced with the Burns Mall.

Traffic Chaos

Portland Street was opened up in the early years of the nineteenth century as an extension to King Street and, as such, was always a busy commercial street. By the 1960s traffic was choking the main commercial streets of the town. King Street and Portland Street became a pedestrian priority area not long after this picture was taken in 1974.

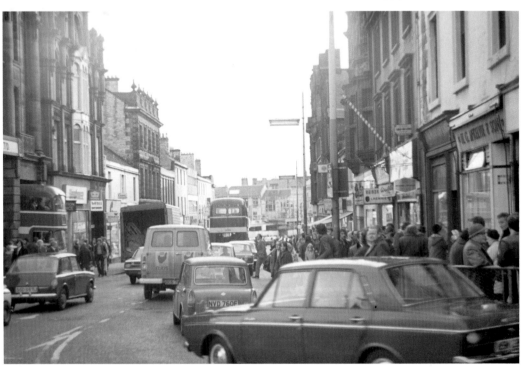

Industries

During the nineteenth century a great transformation took place and the cottage crafts which had been around for generations began to grow into major industries. In Kilmarnock several home-grown industries established a national and often an international reputation. The leather workers were used to producing belts, saddles and all manner of leather goods, but it was boots and shoes that began to dominate their craft (in 1837 local shoemakers made 2,400 pairs of shoes and boots).

In 1840 George Clark's Kilmarnock-based shoe-making company started exporting boots and shoes to Brazil. In this case he used the merchant venture system which allowed producers to use spare capacity on cargo ships. Legend suggests that he used a ship mostly loaded with Kilmarnock whisky. It was a good deal and both Kilmarnock products became popular in Brazil. This side of the shoe business grew rapidly and by 1900, the company had forty shops in Brazil. George Clark's company grew to dominate the domestic trade and it became the main constituent company that made up Saxone, which was a major employer in Kilmarnock for most of the twentieth century.

The early wool spinners made all manner of textile goods. In 1728 Charlotte Maria Gardiner, a half aunt of the 4th Earl of Kilmarnock, brought a group of carpet makers to Kilmarnock from Dalkeith and the town soon earned a reputation for making quality carpets. In 1908 BMK was founded in Kilmarnock and quickly established a reputation of the carpet maker of choice for top venues. BMK remained a major employer in Kilmarnock until 2005 when carpet making in Kilmarnock came to an end.

Engineering grew out of the demands of the coal industry, but it was Glenfield & Kennedy which grew rapidly to become the biggest firm of hydraulic engineers in the British Empire.

Saxone, BMK and Glenfield and Kennedy became known in many export markets but the Kilmarnock business with the widest reach was founded in 1820 by a man who was happy running his little grocery shop. He was Johnnie Walker and the whisky side of his business was built into a global brand by his son and grandson, both named Alexander.

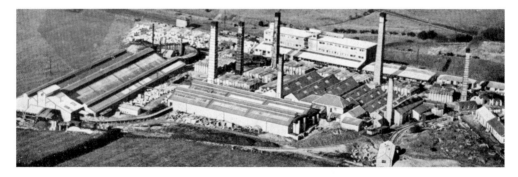

Out of the Earth

Kilmarnock had a long tradition of brick-making and stone quarrying. These businesses also made chimney pots, garden ornaments and features for public parks. One of the large concerns was the Southhook Pottery at Bonnyton. They had their own coal and clay pits and made a wide variety of sanitary and other goods for sale at home and abroad.

Craig

Another of the major manufacturers in Kilmarnock was J. & M. Craig, who also made a wide variety of stoneware products. The public toilets at Rothesay were built by J. & M. Craig of Kilmarnock and are now something of a tourist attraction in their own right. Although still in use, they have been known to be closed to allow lady visitors to see them.

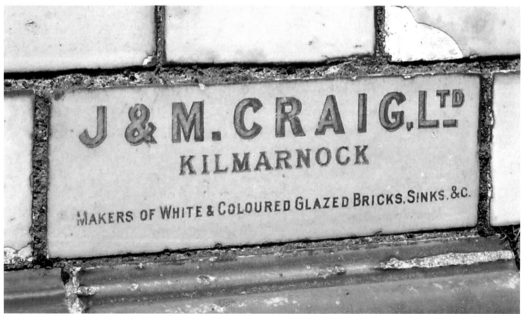

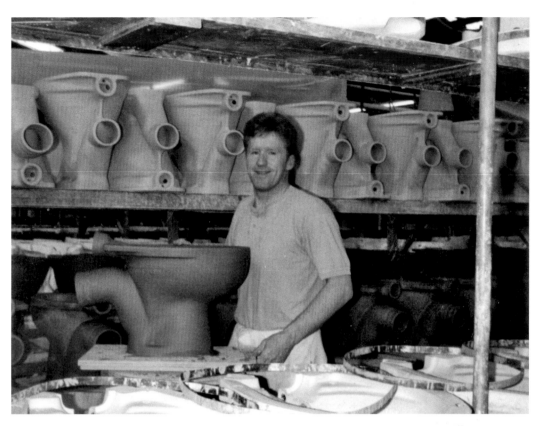

Shanks

Eventually the works of J. & M. Craig were taken over by Shanks, who continued to run the pottery into the 1980s. Pictured is John McClymont of Kilmarnock, who worked with Shanks in Kilmarnock and later at Barrhead.

Weaving a Web

Weaving is an ancient craft and the weavers of Kilmarnock had a protective charter in 1684. Calico printing was introduced to Kilmarnock in 1769 or 1770 and the weaving of silk was started in 1777. The industry grew rapidly and eventually became industrialised. Textile work remained important in the area into the twenty-first century.

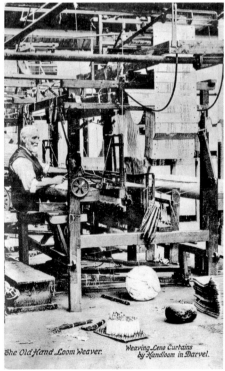

The Old Hand Loom Weaver. Weaving Leno Curtains by Handloom in Darvel.

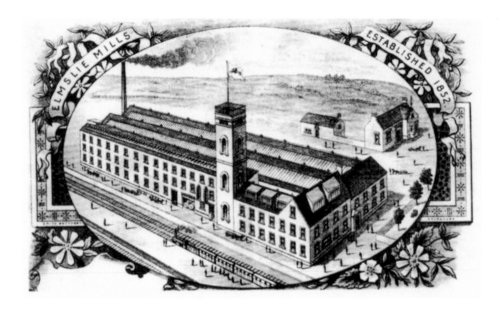

Pyjama Party

James Wyllie, established the Elmslie Mills in Hill Street. His company, Wyllie & Sons, produced shirts, blouses, pyjamas and dresses and quickly built a good export trade. By 1939 the company had moved to West George Street. In 1965 the Kilmarnock operation was closed and manufacturing was transferred, first to Renfrewshire and then in 1979 to England.

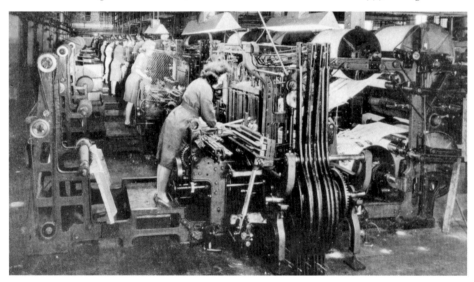

Business Floored

Carpet making was introduced to Kilmarnock by Charlotte Maria Gardiner in 1728. Over the decades various carpet makers flourished. In 1908, with difficult trading conditions in the industry, William Ford Blackwood of Robert Blackwood & Sons, Kilmarnock's last carpet maker, looked for a business partner. He found Gavin Morton, a local textile manufacturer. Together they formed Blackwood & Morton (Kilmarnock), better known as BMK. They earned a reputation for quality carpets. They remained in Kilmarnock until 2005. The picture shows work in the factory in the late 1930s.

BMK Building
BMK had several properties in Kilmarnock. This factory at Burnside Street had distinctive architecture. The building was used by the SAS and commandos for abseil training in 1944. The buildings here were demolished in 1985.

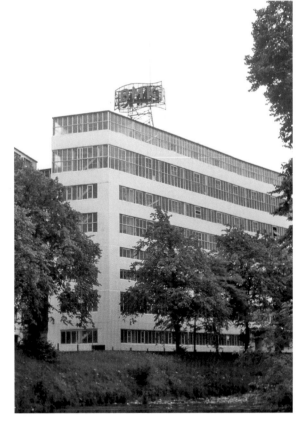

Boots and Shoes
Kilmarnock had a long tradition of shoe making, even when the industry was a cottage craft. At the start of the twentieth century the dominant boot and shoe maker was Saxone, a nationally known brand that was founded in Kilmarnock. This impressive water tower was one of the Saxone shoe factory buildings in Titchfield Street.

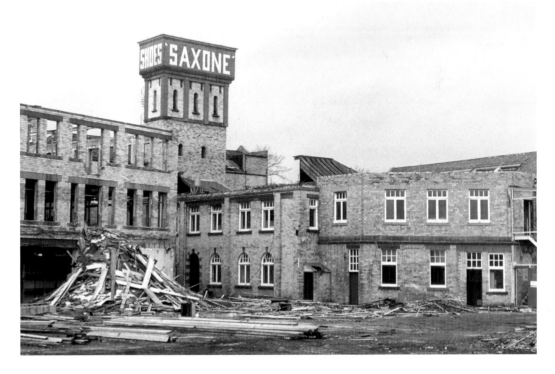

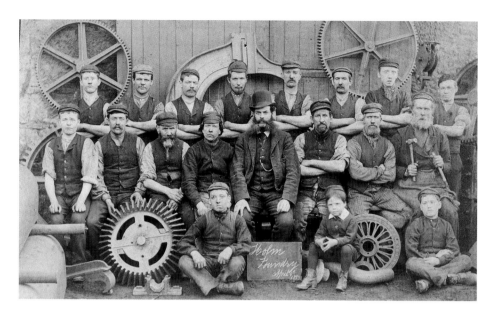

Forging Ahead

Kilmarnock has a long history of engineering industries. The partnership of Rodgers & Blair established the Holm Foundry in Low Glencairn Street about 1840. This picture is from 1893. Look how young some of the lads are.

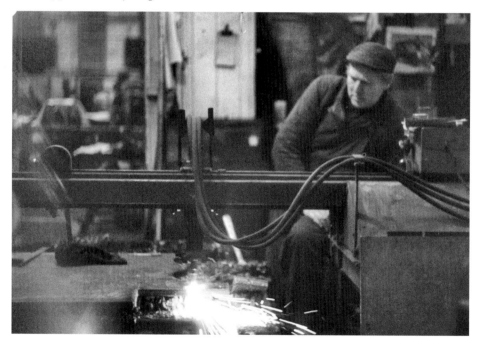

Steaming On

Andrew Barclay established his engineering works in Kilmarnock in 1840 and, although involved in many engineering products, the firm gained an international reputation for building steam locomotives and later diesel and electric locos. There have been several changes to the name but loco engineering continues in Kilmarnock.

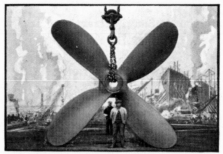
Ship Shape

In 1864 Andrew Strang established what later became known as the Blair Foundry at Hurlford. One of their specialities was large ship propellers. In 1971 the company made the six-bladed propeller required for the restoration of the SS *Great Britain*. Today a large propeller stands at Hurlford Cross as monument to local industrial heritage.

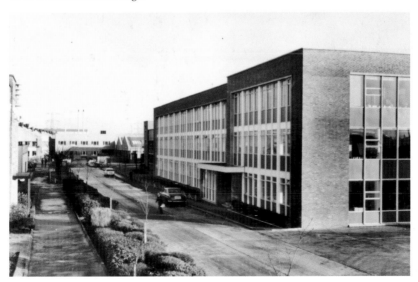

Metal Work

Glacier Metal set up in Kilmarnock in 1942, having moved from London to escape possible damage from air raids. The firm stayed in Kilmarnock after the war and moved to their present site at Riccarton in 1947 on the land of the former Kirkstyle coal pit. Today the successor company is known as Mahle and is still located at Riccarton.

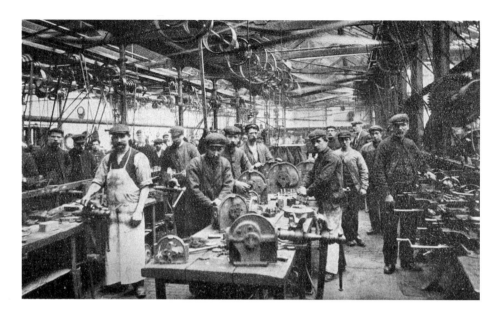

Glenfield...

In 1852 Thomas Kennedy patented an improved water meter and soon founded two companies to manufacture the material and the meters. The two firms were later merged to form Glenfield & Kennedy. By then they produced any materials and works involved in the flow and control of water. This picture shows work going on inside the plant around 1908.

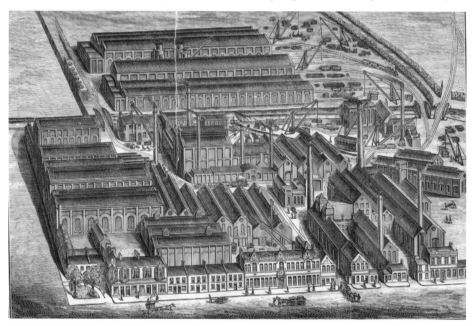

...& Kennedy

The Glenfield works continued to expand and at their height they were the biggest makers of hydraulic products in the British Empire. The firm was a major employer in the town and had a reputation for treating employees as a family. In the Kilmarnock area the business was always known simply as The Glen.

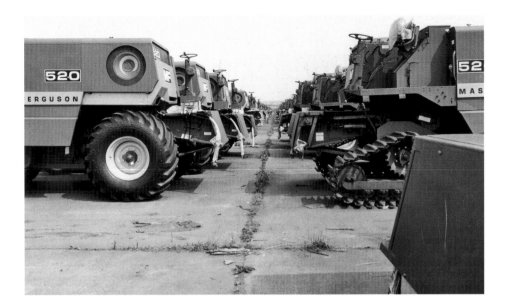

Massey Harris

In 1949 tractor builders, Massey Harris were attracted to the Kilmarnock area largely because of the availability of a workforce that was already skilled in engineering trades. They established an assembly plant at Moorfield Industrial Estate between Kilmarnock and Gatehead. The business became Massey Ferguson and grew rapidly to become one of the major employers in the area.

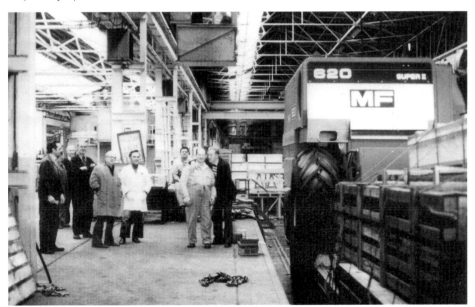

Bitter Blow

In 1980 Massey Ferguson closed their Kilmarnock plant with the loss of 1,500 jobs. It was one of the most severe blows Kilmarnock industry has ever suffered. Pictured is Richard Ross with work colleagues, with the last combine harvester built at Kilmarnock. With the closure, Massey Ferguson helped set up Moorfield Manufacturing, which gave work to 200.

Right Spirit

In 1819, following the death of his father, fifteen-year-old Johnnie Walker was set up by his trustees in a grocery shop in Kilmarnock. He became very adept at blending different types of tea ... and whisky. His son and grandson, both named Alexander, built the company into one of the world's first global brands. At one time all aspects of the company's work were carried out in Kilmarnock. They even had their own coopers.

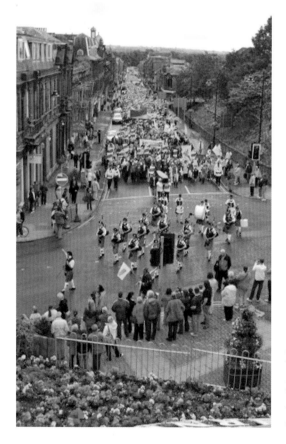

Spirited Away

In the summer of 2009, the parent company, Diageo, announced that Johnnie Walker was to pull out of Kilmarnock altogether, with hundreds of job losses. This provoked a mass protest. However, the phased closure is expected to be completed by the summer of 2012.

Transport

It is hard for us to imagine a time when there were no good roads. Until the middle of the eighteenth century there were only rough tracks to link Kilmarnock with neighbouring communities. These tracks were narrow and twisting, and at times impassable. The first Ayrshire Turnpike Act was passed in 1767, allowing many of the old tracks to be widened and improved by turnpike trusts who were also responsible for the building and repair of roads. Several new or improved roads soon followed. This involved the roads from Ayr and Irvine to Kilmarnock, and roads from Kilmarnock to Stewarton through Kilmaurs, to Galston and from Kilmarnock and Kingswell to Flockbridge.

A second Ayrshire Turnpike Act was passed in 1774 and named thirty-nine new roads for the county. This involved several roads in the Kilmarnock area, including the road from Fail to Riccarton; Kilmarnock to Dundonald; Kilmaurs to Symington and the road from Hurlford to Riccarton. With road building improvements pioneered by Ayrshire man, John Loudoun Macadam, trade began to pick up and because roads were better, people needed new carts. It looked like a boom time thanks to the roads. But at the start of the nineteenth century there was a rival. The Marquis of Titchfield, later 4th Duke of Portland, wanted the best way to transport coal from Kilmarnock to Troon, for onward shipping.

Scotland's first railway was built between Kilmarnock and Troon between 1808 and 1812, and it had a regular passenger service from before construction work was completed. It also had a steam locomotive in 1816, though it was not successful at that time. Railways came to dominate the country's transport in the nineteenth century but the invention of the internal combustion engine saw the start of a shift back to the roads. The twentieth century saw passengers move from railways to roads as well, through the use of buses and trams.

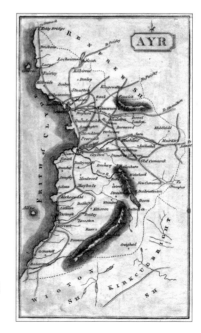

Mapped Out
This map dates from the eighteenth century, before Kilmarnock became a major industrial hub. Even so, the typeface used suggests that Kilmarnock is the only inland town with the same importance as coastal towns. Note that Troon has not yet been developed as a harbour.

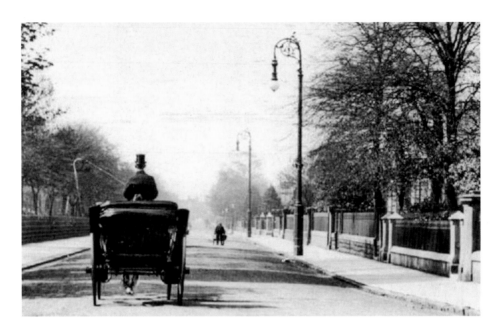

Horse and Carriage

There was a time when the only two options for getting around were to walk or use a horse. Later on there was the luxury of using a carriage or a coach. This picture of a horse and carriage in Dundonald Road, Kilmarnock, was taken at the start of the twentieth century, just as motor cars were replacing horses.

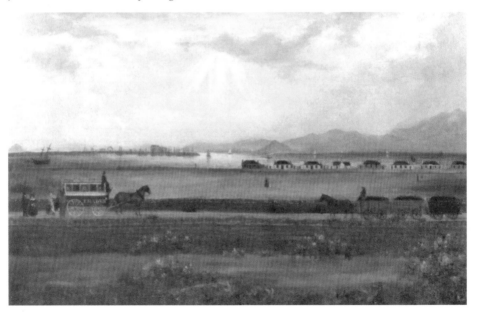

Rails to Troon

The Kilmarnock & Troon Railway was built between 1808 and 1812 for taking coal to the harbour at Troon, but it carried passengers from 1812. This painting from East Ayrshire Council Museum & Galleries collection shows passenger and freight working on the line at a time when motive power was still provided by horses.

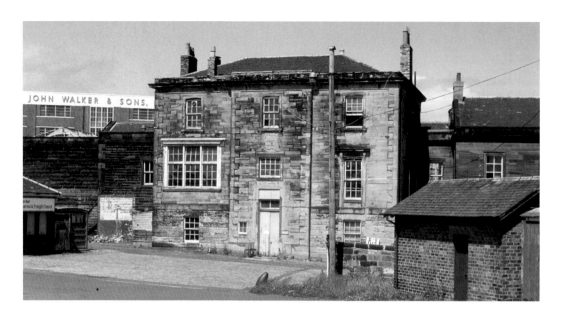

Rail Progress

The national railway network came through Kilmarnock in 1843 when the Glasgow, Paisley, Kilmarnock & Ayr Railway was opened. This station building dates from that time. It was controversially demolished in 1995.

All Steamed Up

The second half of the nineteenth century saw a rapid expansion of the railway network and the emergence of the Glasgow & South Western Railway Co., which was the main operator in Kilmarnock. By 1900, you could travel to just about anywhere in the UK by train. Until the 1960s most services were steam hauled.

Trained Up

The railways had to adapt to competition from buses and then to the rise of the motor car. Railways were taken into state ownership in 1948, but later sold back to private operators. The railways remain an important part of the national infrastructure. Today, Kilmarnock railway station is operated by First ScotRail which, of course, provides services in all weathers.

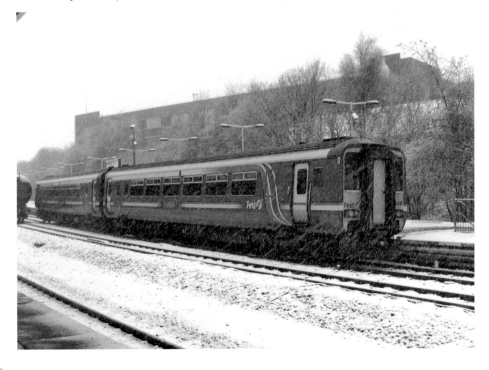

Cycle Pioneers

The world's first bicycle was built by Kirkpatrick McMillan from Thornhill, near Dumfries, in 1842. Later, one of his neighbours, Thomas McCall, came to Kilmarnock to work for Thomas Kennedy, but around 1869 he was making bicycles commercially in Kilmarnock. The popularity of cycling grew enormously. Various other bicycle makers set up in Kilmarnock and it was a group of Kilmarnock cycle makers who went to Coventry to start a similar industry there.

The Shooglies

Just before the era of motoring, Kilmarnock had its own tram service. It was a small system with only thirteen cars and it was short-lived, only lasting from 1904 to 1926. But the system did introduce the idea of commuting and it created new housing developments along some parts of the system.

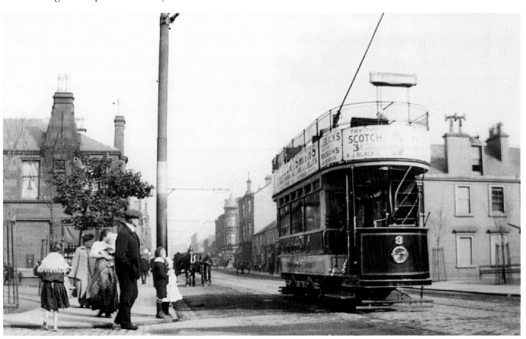

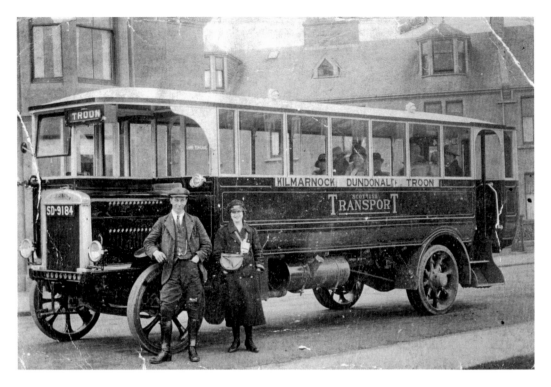

On the Buses

The first motorised bus service in Kilmarnock was launched by Dick Brothers in 1897. Dick Brothers were soon joined by other operators and before long there was an extensive choice of destinations. By the time this picture was taken in 1925 there were national bus operators.

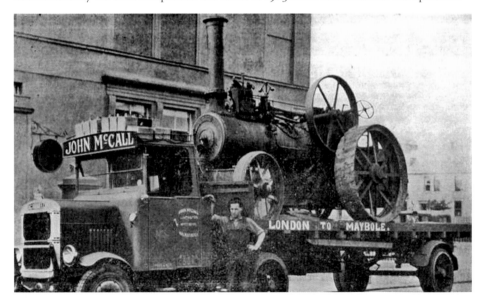

One for the Road

There were several specialised road-haulage businesses in Kilmarnock. This picture, from around 1946, shows a traction engine on a flat-bed lorry used by local firm John McCall.

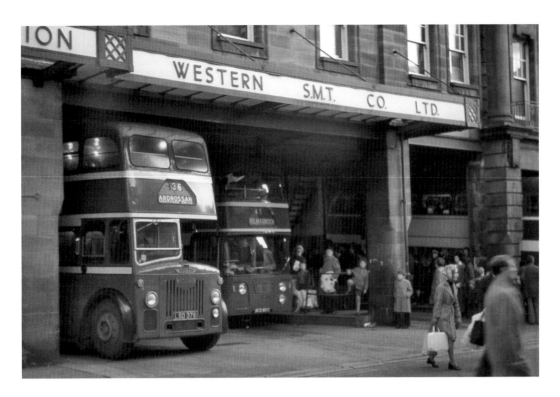

Transport Station

Kilmarnock's grandly named Transport Station (above) was one of the first custom-built bus stations in Scotland. It opened in 1923 and served as the town's main bus station until it was replaced by today's bus station (below) in 1974. Today over-60s are encouraged to use free bus travel to any destination in the country in a scheme subsidised by the Scottish government.

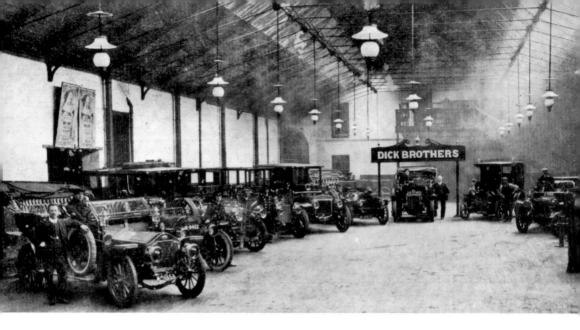

New Transport

The local business of Dick Brothers was founded in 1895 as cycle agents but before the end of the century cars were becoming more common and the company quickly adapted to this new technology. By 1909 they had so many cars on show they had to hire space in the town's Agricultural Hall to display them (above). The picture below was taken at their premises in Green Street. Buildings there were demolished in the 1970s.

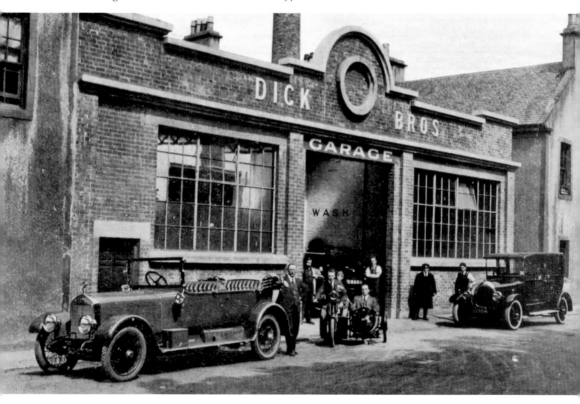

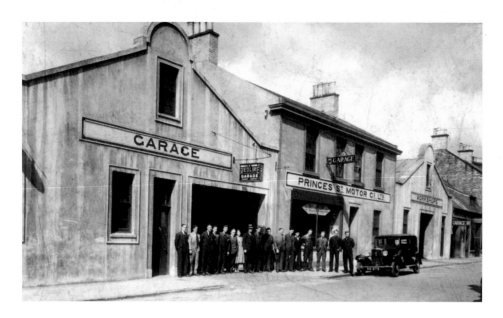

Street Cars
Aird Brothers garage was well established when the business was sold to Andrew Auld in about 1930. The property was at the corner of Princes Street and Fowlds Street, so the new owner changed the name to Princes Street Motors. This business survived until the end of the 1970s when the site was cleared for a supermarket.

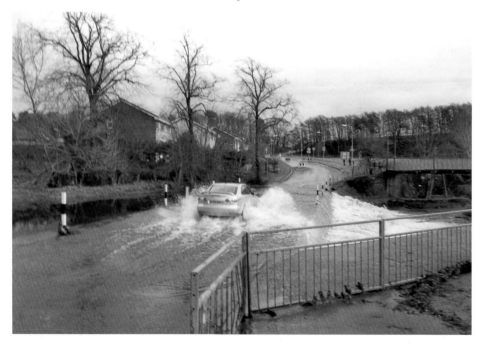

Ford Crossing
The ancient ford at the Dean has been reshaped and adapted many times, but in recent years too many motorists have found themselves stranded and the ford is soon to be replaced by a bridge.

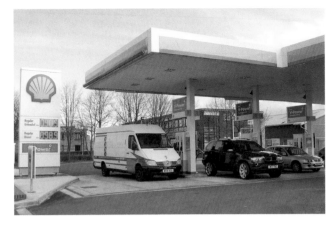

Petrol

For most of the motoring era petrol station attendants would come and fill the tank for you, but today motorists have to fill up themselves. This picture was taken in 2009. Note that petrol and diesel were still below £1 a litre.

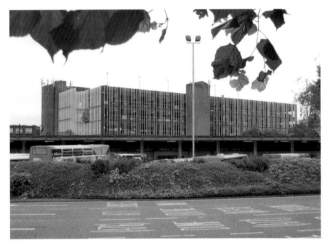

Parking

As more and more vehicles came on to the roads, finding space to park them all was a problem. This multi-storey car park was opened in 1975. At the time it was planned to be the first of several around the core of the town, but today remains the only one that was built.

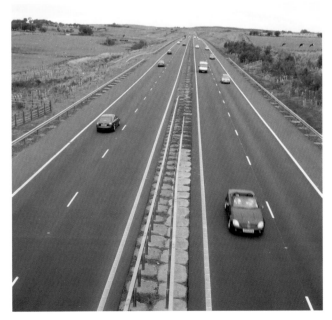

Motoring On

The towns of Ayrshire are well linked with modern dual carriageway roads. The M77 motorway, left, from Meiklewood between Kilmarnock and Fenwick, to Newton Mearns, south of Glasgow, was opened in 2005, thirty years after being suggested. The new section of the M77 gave people in the Kilmarnock area a direct link to Glasgow city centre and access to Scotland's motorway network. The idea of a long, straight section seen here might well have appealed to the Romans.

At Your Service

Public services are all around us, so much so that we hardly notice them, except when we have to pay our tax bills. In 1735 Kilmarnock magistrates implemented the town's first scheme for public street cleaning. It only related to 'the causeys and public streit at the mercat place' on such occasions as it needed cleaning. This scheme was funded by voluntary contributions which were collected annually. Other early forms of public service included street lighting and there was a form of lighting even before Ayrshire man, William Murdoch, first started using gas. Before gas, lamps were made of straw bales hung from a lamp post, and set alight. At different times some services in private hands have been taken into public ownership and some in public ownership have been sold to private operators. This does not just relate to the massive national corporations that were created on nationalisation in the 1940s and sold back to the public a generation later.

When new services such as water, gas and electricity were to be introduced there was often an argument about whether that service should be run by a private or a public body. The Kilmarnock Water Company was set up as a private company in 1846, under an Act of Parliament. Water and sewage services later became a public concern. The Kilmarnock electric works and the tram system were set up in 1904 by the local council.

In the nineteenth century the town had several private libraries, set up by charitable groups, but they were merged and became a public service. The Dick Institute was opened in 1901 as Kilmarnock's cultural centre and today is still a library, art gallery and museum. Health and education are in the public sector and have often been political footballs. Today in Kilmarnock the schools are all under the authority of East Ayrshire Council and the hospitals and health services under the care of Ayrshire and Arran NHS Trust.

In 1800, as a result of a spate of attempted break-ins, the magistrates of the burgh decided to establish a guard consisting of nine local people, three men from the military volunteers and a special constable. It was the start of the Kilmarnock police force. In 1753 the magistrates of the town agreed to buy a 'water machine' for extinguishing fires; it was a pump-action horse-drawn cart and came with 40 feet of leather hose. The water was carried in an on-board tank. At the same time a volunteer force was recruited to help fight any outbreaks of fire in the town. It was the start of what is now a highly professional Fire & Rescue Service.

Responsibility for fire and police services began with the local control in towns but has gradually been centralised. Today both are facing the prospect of becoming national rather than regional services.

Lighting Up

Lighting the town's streets goes back a long way. The Kilmarnock Gas Company was formed in 1822. In the twentieth century an electric power station was built in Kilmarnock in 1904.

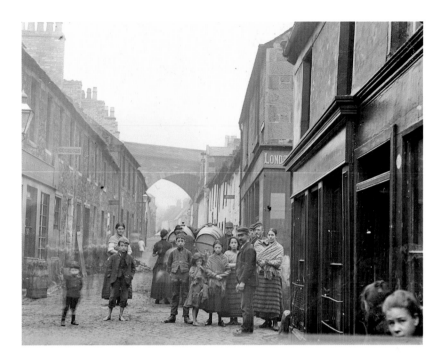

Social Problems

This late nineteenth-century photograph shows some of the social problems facing society at the time, particularly the overcrowding in the narrow street and the fact that at least one young lad has no shoes.

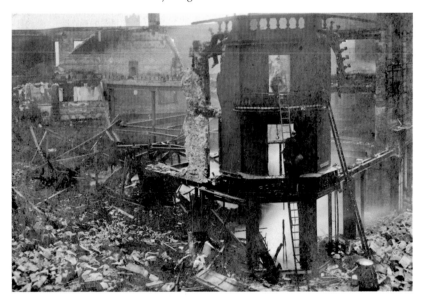

Shop Blaze

This is the immediate aftermath of a devastating fire which destroyed the shop and warehouse of the drapery business of Andrew Ross & Co. in 1921. The site, on the corner of Portland Street and East George Street, was soon cleared. Before the end of 1923 the town's new bus station had been built there.

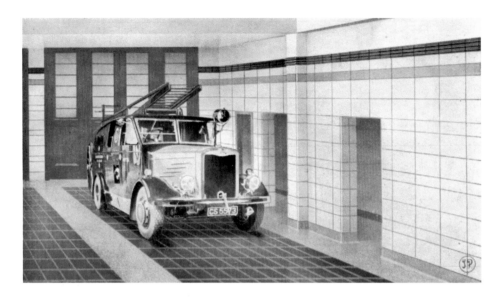

Well Prepared

Locally organised firefighting goes back to at least 1753 when town magistrates bought a 'water machine' for extinguishing fires. Firefighting continued to develop. This picture inside the town's fire station was taken about 1937. Kilmarnock pioneered the idea of firemen sitting inside the vehicle.

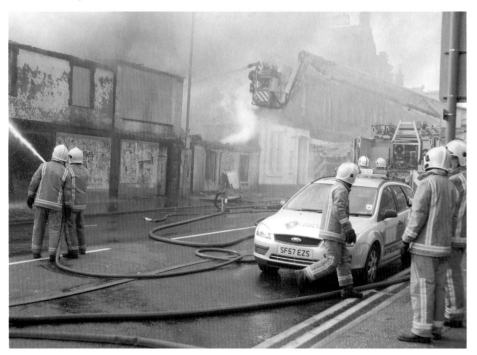

Fire! Fire!

Firefighting today is more sophisticated than ever before and the men and women who work in the Fire & Rescue Service are better trained. This picture from 2008 shows the service tackling a blaze in derelict properties in High Glencairn Street.

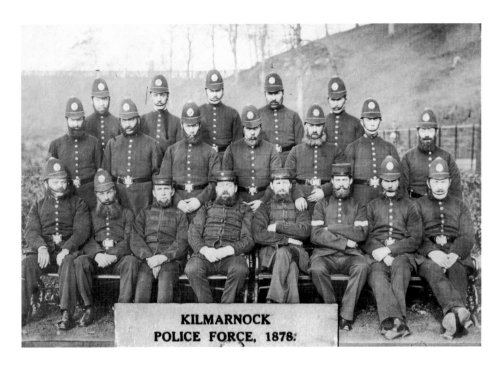

Cop That

An Act of Parliament of 1810 gave various powers to the Burgh of Kilmarnock including lighting, cleansing, and 'watching' – which meant policing. The Burgh Police force grew in strength and soon became a full-time professional organisation.

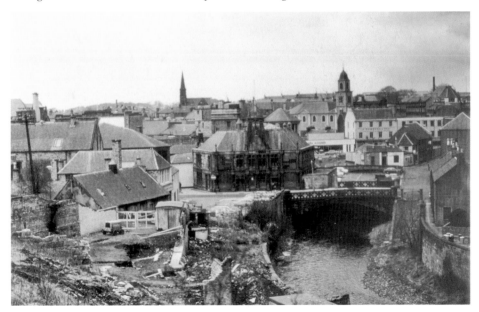

Station House

The central building in this 1970s picture was the Burgh police station, which was opened at Sturrock Street in 1898, replacing the earlier police base in part of the town hall in King Street. The building also served as a Burgh Court.

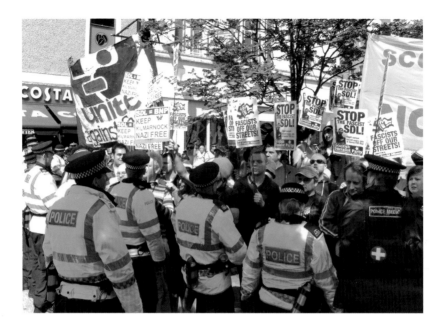

On the Streets

When an extreme right-wing group planned a demonstration in Kilmarnock in 2009, a counter demonstration was immediately organised by political parties, trade unions and others ... and, of course, the local police were called in to ensure that the two groups were kept apart.

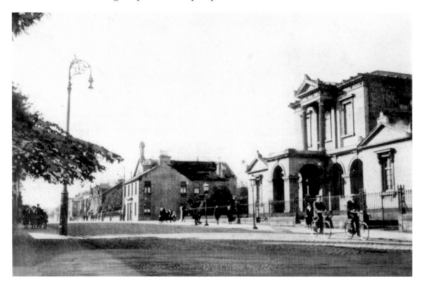

In the Dock

Benjamin Bell was appointed the first Sheriff Substitute for Kilmarnock in 1846. This meant that the town was able to hold jury trials, the first of which was on 21 September 1847. In 1852 a Sheriff Court House and a jailhouse were opened on land at the corner of Bank Street and Saint Marnock Street. A new Sheriff courthouse was opened in 1986 and this allowed the High Court to meet in Kilmarnock for the first time in 1987.

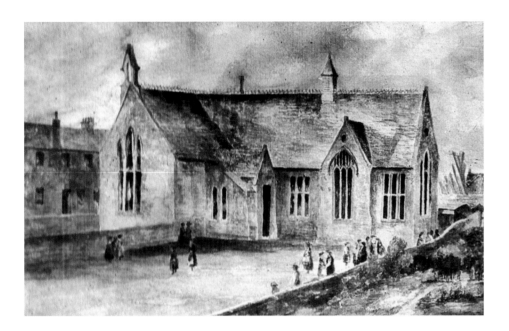

Good Schooling

Scotland has long recognised that education is a sound investment for the future, and in 1633 the Scottish Parliament – the original one – passed an Act to establish a school in every parish in the country. This painting shows one of the two Kay Schools opened in 1869. The money came from Alexander Kay, who also left money for a park, now the Kay Park.

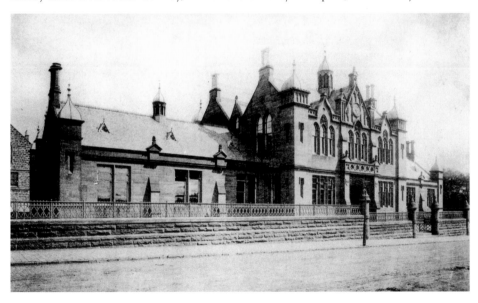

Academy Building

The schools run by the Burgh and the parish church were merged in 1808 to form Kilmarnock Academy. It was built on land at the corner of Green Street and London Road. In 1876 the school moved to a new home, pictured here, at the corner of North Hamilton Street and Woodstock Street. The building was designed in Elizabethan Gothic style by architect William Railton.

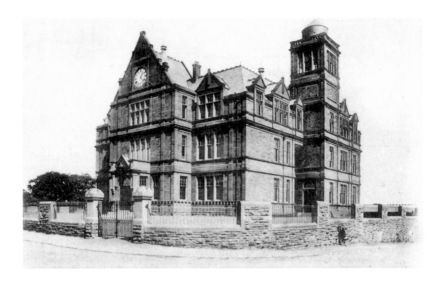

New Academy

Kilmarnock Academy moved from the North Hamilton Street to the hill at Elmbank Avenue and Braeside Street. The old building is still part of the Kilmarnock Academy campus. Two Kilmarnock Academy students have gone on to win Nobel Prizes. Today, nearly all children in Scotland get their education through the state system in schools run by the local authority.

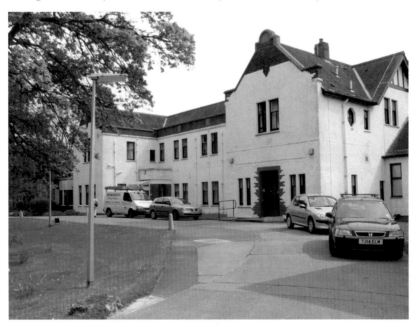

Home Care

Strathlea Resource Centre for people with mental health problems was opened at Holmes Road in 1991, in what had previously been the Kilmarnock Maternity Home. The residential complex, under the auspices of Ayrshire and Arran Health Board, had various innovative features and services and was the first of its kind in Scotland.

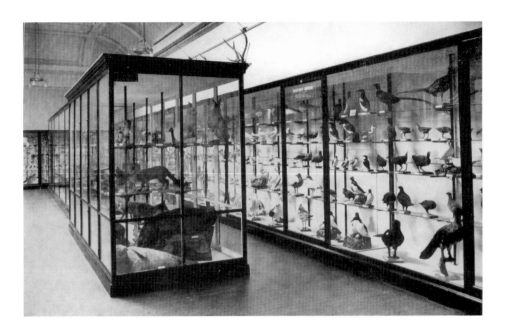

Culture

The Dick Institute was opened on the site of Elmbank House as Kilmarnock's cultural centre, housing a museum, an art gallery and a library. It displayed the nationally important Thomson collection of fossils and geological specimens. Another speciality was the collection of stuffed birds. Money for the project came largely from James Dick, 1823–1902, who saw the Dick Institute as a memorial to his brother Robert, 1820–91. The brothers were born in Kilmarnock and made a fortune through the firm R. & J. Dick in Glasgow, which made products from the rubber material, gutta-percha.

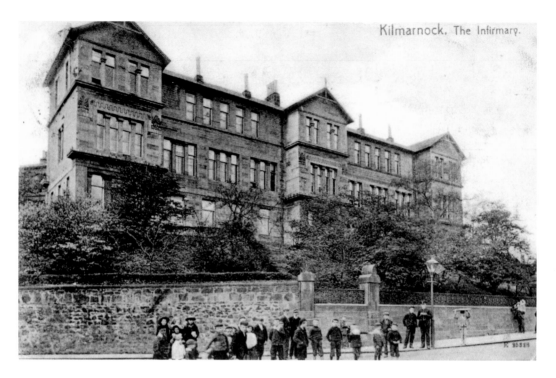

Kilmarnock. The Infirmary.

Healthy Option

The original part of Kilmarnock Infirmary (above) was opened at Mount Pleasant in Wellington Street largely with the help of public subscriptions. It had only twenty-four beds, one matron, two nurses and Dr Borland as the Medical Officer. It was extended on several occasions and closed in 1982 when a new general hospital for all of north Ayrshire was opened at Crosshouse. In 2006 Ayrshire's maternity services were centralised in a new facility adjacent to the hospital at Crosshouse.

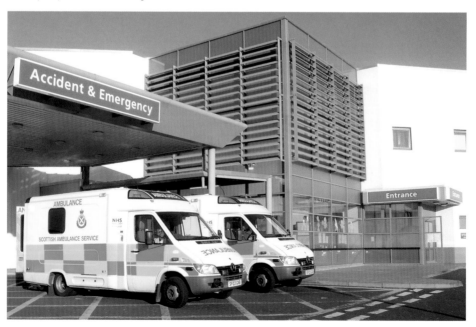

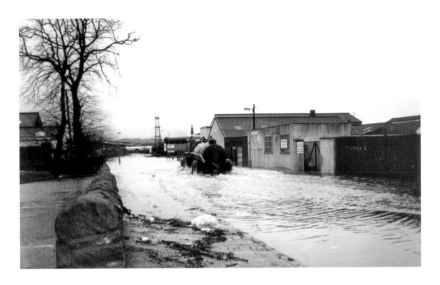

Water, Water Everywhere

In 1994 Kilmarnock was hit by the most severe flooding in sixty years. Together, the River Irvine and Kilmarnock Water flooded many streets and properties. Further severe flooding in 1995 led to a diagnostic survey and within a few years various flood management schemes in low-lying areas of the town were put in place.

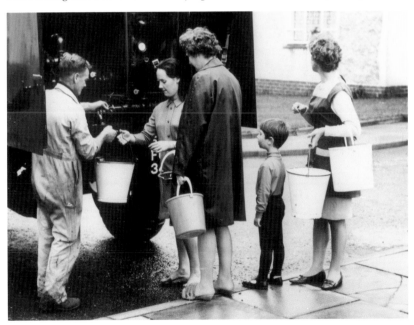

Nor Any Drop To Drink

In 1846 An Act of Parliament gave powers to allow the formation of a Kilmarnock Water Company and for them to take water from Dinnan's Burn and others streams in the Fenwick area to supply Kilmarnock and its surrounding villages. It also allowed the construction of North Craig and Gainford Reservoirs. In 1969 Ayrshire suffered a severe drought and water had to be distributed through tankers.

War and Conflict

Charles Ewart was one of many Ayrshire men who went off to Europe to fight in the Battle at Waterloo. Ensign Ewart distinguished himself in fierce hand-to-hand fighting and he emerged with the French standard, a trophy still held at Edinburgh Castle.

In later years, men from Kilmarnock also distinguished themselves in battle, in South Africa and in other places where the British Establishment enforced their will in creating an empire. The dawn of the twentieth century saw a new kind of warfare, one that saw slaughter on an unprecedented scale; and yet young men willingly signed up and went off to find that life in the trenches and the battles with the enemy was a matter that was far from glorious. That war, the First World War, touched the lives of every citizen of Scotland. Everyone knew someone who had been killed or maimed, or had otherwise been affected by the war. As the men went off to fight, the women took their places on the trams, in the shops, the banks and in the factories. And still, war was remote from the civilians.

A Second World War changed that. Everyone was involved. At school Kilmarnock children had to get used to sharing their classrooms and often their homes, with children from Glasgow as the shipyards of the Clyde were a prime target. Everyone had to learn to use a gas masks, and to learn where the nearest air-raid shelters were. They also had to grow as much of their own food as possible and had to learn to make do and mend.

Kilmarnock industries rose magnificently to the challenge. Saxone manufactured army boots; the engineering businesses produced a wide range of military equipment; Glenfield & Kennedy designed and installed special floodgates for the London Underground as well the valves required for PLUTO, a cross-channel pipe that kept the Allies provided with fuel after the D-Day landings. BMK switched from making carpets to making shells for the military.

Today's annual Remembrance service is held at the town's war memorial, which has the names of local men killed in two World Wars as well as other conflicts in Korea and Northern Ireland.

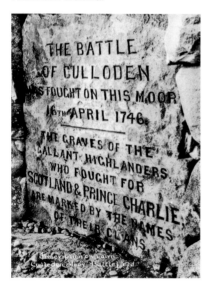

Rebel Laird
In 1745, William Boyd, 4th Earl of Kilmarnock, backed the second Jacobite rebellion. As with the first rebellion, the people of Kilmarnock supported the crown. The earl took part in the battle at Culloden and was arrested. Because of his rank, he was put on trial for treason. He was found guilty and was executed in London in August 1746.

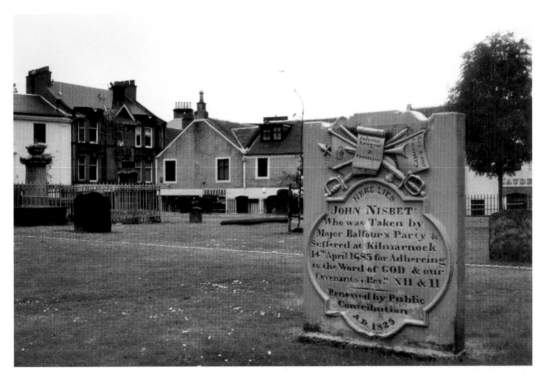

Killing Time

In 1638 King Charles I tried to impose on Scotland the English style of worship and church management, with the King as the head of the church. Most Scots resisted the idea, saying that the only true head of the church was God. The Solemn League and Covenant was drawn up in 1643 to the resist the King's plans. Supporters were the Covenanters. There followed 'the killing time'. Anyone resisting the King's forces could face transportation or even summary execution. Resistance was particularly strong in Ayrshire and Lanarkshire. Notice the inscription on the stone for Ross and Shields. Only their heads are buried locally.

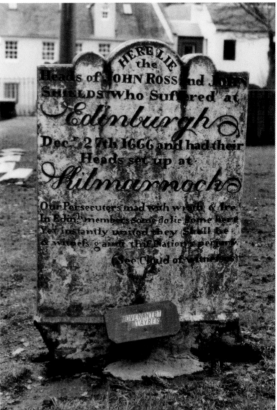

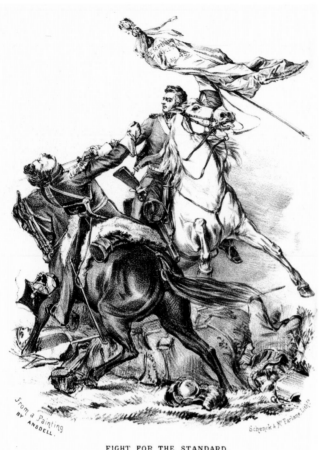

FIGHT FOR THE STANDARD.

Waterloo

Ensign Charles Ewart was born in Kilmarnock and like many other Ayrshire men he found himself in the Battle of Waterloo in 1815. The battle changed the course of European history. One of the legends of that battle grew out of Ewart's heroic struggle, which ended with him seizing the French Standard, a war trophy still on display in Edinburgh Castle.

Votes at Last

After a long and bitter campaign, Parliament passed the Reform Act, allowing about 60,000 men in Scotland to vote in parliamentary elections. In the Kilmarnock Burghs parliamentary seat, John Dunlop took 297 votes and his rival, James Campbell, took 262. The reforms fell far short of the universal franchise that most of the campaigners had hoped for, but further major extensions to the franchise came in 1867, 1884, 1918 and 1928. This statue was put up in Kay Park to commemorate the efforts of the early reformers.

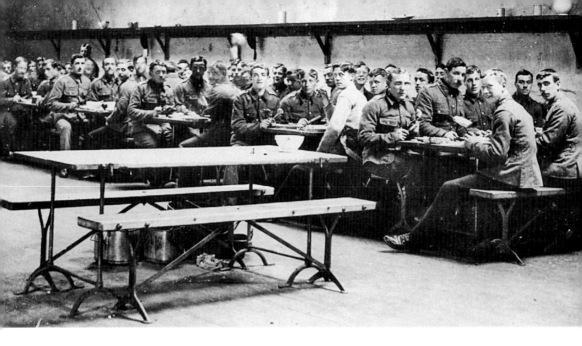

Army Camp

In 1911, Territorial Army units from all over the south-west of Scotland came to Kilmarnock for a two-week camp at Woodhead, near Riccarton. The camp even had its own post office. Soon, in common with cities, towns and villages across the country, young men were enticed to join up and fight for King and Country in the First World War. The two pictures here show the men of the Black Watch.

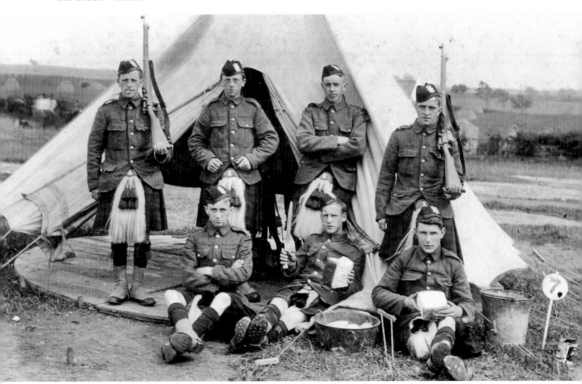

Boer War

In 1900 members of the 1st and 2nd volunteer battalions Royal Scots Fusiliers left Ayrshire for South Africa to fight for Queen and Country. Five of their number were killed in action, including L/Cpl John Risk from Kilmarnock. The volunteers returned home on 10 June 1901 to a thunderous welcome from the people of the town. They were treated to a dinner in the George Hotel and each one was given a gold medal from Kilmarnock Town Council.

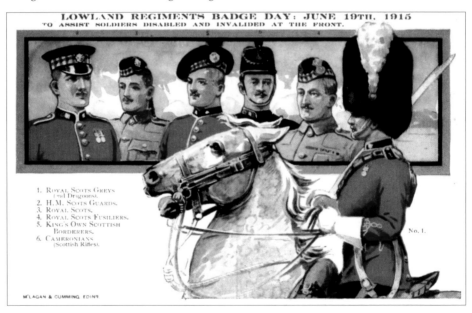

Maimed

The slaughter and maiming in the Great War was unprecedented and soon the injured men started to return home. This postcard marked the badge day on 19 June 1915 which helped raise cash for soldiers from the Lowland Regiments of Scotland who were disabled in the conflict.

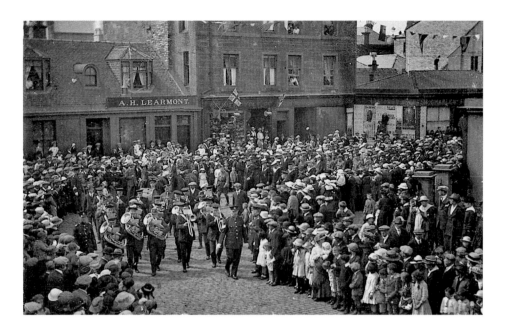

Peace Day

On 19 July 1919, festivities were held to celebrate the peace following the armistice of 11 November 1918, which ended the war with Germany. There was a service in the Laigh Kirk. After a parade through the town by representatives of local organisations, a peace tree was planted in the Howard Park and a service held there. At the Agricultural Hall, 1,000 local soldiers were entertained.

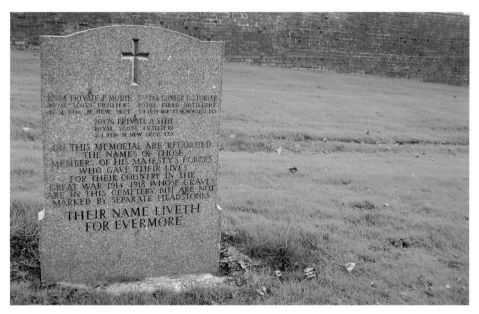

Memorial

Many memorials and gravestones remember those who died in the conflict. This stone in Kilmarnock cemetery lists the soldiers who were buried there without their own headstones.

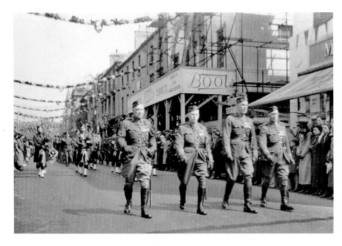

Ready for War

As the 1930s drew to a close another war was looming and military preparations were obvious on many levels. Military units are seen here in King Street, Kilmarnock, during a parade in 1937 marking the coronation of King George VI.

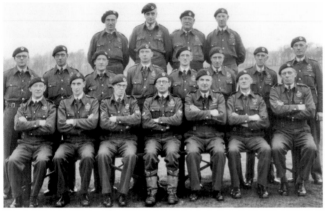

Skywatch

The Royal Observer Corps was one of many groups which had a vital role to play in the defence of British towns and cities. These are the men of Post H4 Group 34 of the ROC, photographed in November 1944. They were based at Grassyards Road in Kilmarnock.

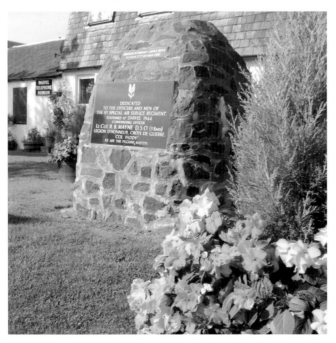

Special Forces

Special Forces including the SAS and commando units from various Allied countries came to Ayrshire for training. Among other features, they used tall buildings for abseiling exercises, they trained in moorland around the town and they used derelict buildings for rescue exercises. They also had water training in the local swimming pool which had a unique locally engineered wave making machine. The picture shows the Darvel SAS memorial.

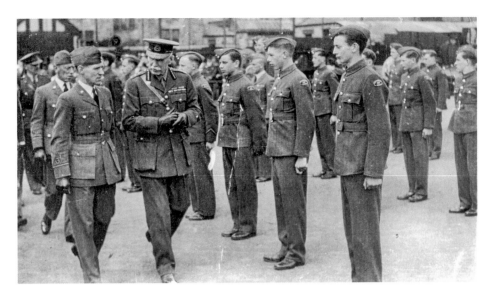

Air Training Corps
One of the groups from the time of the Second World War that is still with us is the Air Training Corps. Here the young men are being inspected in 1941. Today, young women train alongside the men.

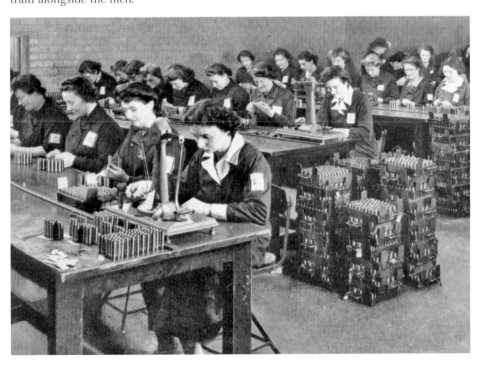

Industry at War
Kilmarnock industries rose magnificently to the challenges of war. Saxone produced army boots, Glenfield & Kennedy invented floodgates for the London Underground, and made the valves required for PLUTO – the pipe that supplied allied troops with fuel after D-Day. The picture shows workers at BMK which switched from making carpets to making shells.

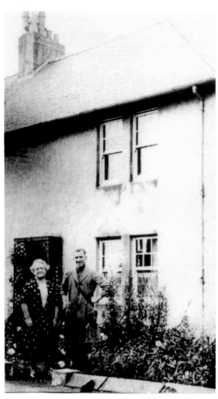

Death from the Sky

In 1941 a Luftwaffe air raid on Kilmarnock left four people dead at Culzean Crescent. They were the only air-raid victims in Kilmarnock during the war. It is thought the bombs were dropped by an aircraft which had taken part in heavy raids on Clydebank. Kilmarnock was not, apparently, a prime target. The victims were a Janet McGeachie, her daughter Alice McGeachie, John Bissett and Dorothy Armour. In 2009 as part of a school study of the war years, children of P6 and P7 at Gargieston Primary School arranged to have a memorial bench placed in Culzean Crescent. Pictured left are Janet McGeachie and son Edward outside the house that was later bombed, and below you can see the bench and the children of Gargieston School.

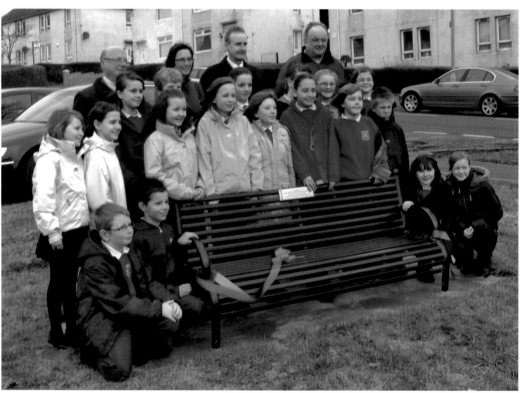

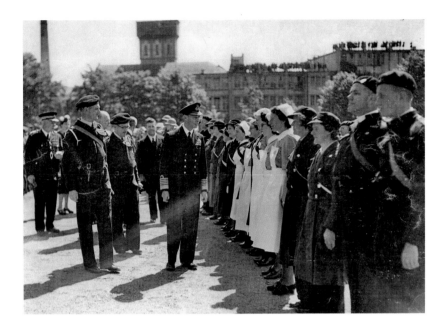

Royal Inspection

War-weary people were given a morale boost in 1942 when King George VI visited the town and inspected representatives of organisations at a special event in the Howard Park.

Remember Them

Towns and villages all over the country built war memorials to honour those who died during the First World War. The Kilmarnock war memorial was opened in 1927. Today it includes names from the First and Second World Wars as well as other conflicts such as Korea and Northern Ireland. Each 11 November the war memorial is the focus of the observance of Remembrance Day.

Sport and Leisure

Kilmarnock is well served with public parks, the main ones being Kay, Howard and Dean Parks, and the Dean Castle Country Park. Although in the care of East Ayrshire Council, the land for these parks was passed to public ownership or paid for by land owners and successful businessmen. The Dean Castle sits at the heart of a country park and, with its ancient history and internationally acclaimed collections of musical instruments and medieval armour, is the area's top tourist attraction. Land that became Kay Park was paid for by Alexander Kay, along with money for two schools. The park was opened in 1879. It contains the Burns Monument Centre and a monument to political reformers.

Land at Wards Park and Barbadoes Green was originally part of the grounds of Kilmarnock House. The park was given to the town by Lord Howard de Walden and opened in 1894. It contains a grave to victims of cholera, a memorial to Doctor Alexander Marshall and a town twinning memorial.

All manner of sports have been well catered for over the years. When Kilmarnock's public swimming pool was opened in 1940, a unique feature was the wave-making machine. That swimming pool has now been replaced with the Galleon Leisure Centre, which offers not just swimming, but facilities for all manner of sports. Football continues to have a passionate following and Kilmarnock Football Club play their SPL games at Rugby Park. Rugby, cricket, tennis, martial arts and other sports all have their local teams. Scotland, it is said, is the home of golf and curling and the town has two municipal golf courses and is home to the new world class Rowallan Golf course, which has a real nineteenth hole to settle drawn games. Curling used to be played out of doors when winter weather allowed, but today enthusiasts can enjoy the roarin' game indoors and all year long. The first serious effort to manufacture bicycles was in Kilmarnock and the area has had several cycling clubs over the years.

Kilmarnock Bowling Club was founded in 1740 and is still going strong and for track events a new stadium built to Olympic standards will be ready by summer of 2012.

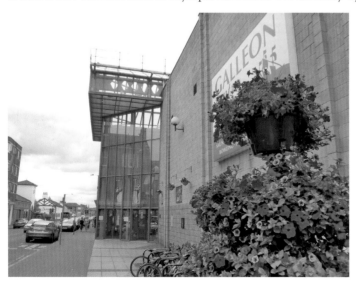

Sports Hall
Galleon Leisure Centre was opened in Titchfield Street, 1987, on land that had been occupied by the Saxone shoe factory. It gives the people of the area a swimming pool, ice rink for curling and skating, bowls hall, and other games. The name was inspired by the nearby Gallion Burn, which is now closed over.

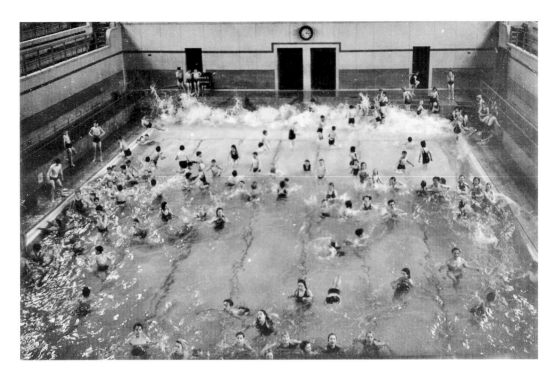

Making Waves

Kilmarnock's public swimming pool was opened in 1940 and had a unique feature: a wave-making machine invented by local engineers Glenfield & Kennedy provided waves which constantly changed their shape. The machine was only ever turned on for a few minutes at a time, but it was hugely popular.

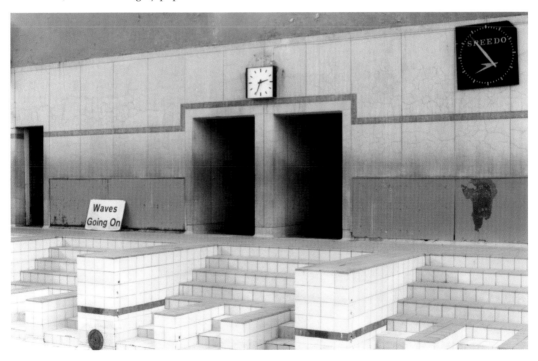

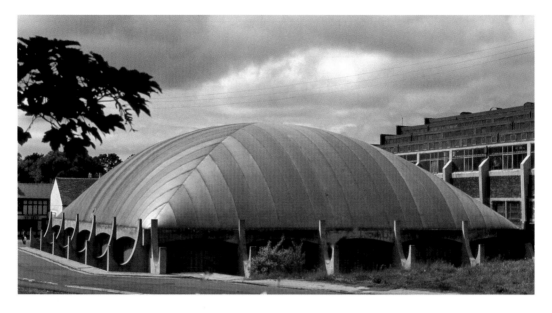

The Bubble

The so-called Bubble sports hall was an annexe to the swimming pool in Titchfield Street. Built in the 1970s, it was kept up by pressurised air and patrons had to go through an air lock to use the facilities. The Bubble was damaged by a storm in 1986 and was taken down soon after when both it and the swimming pool were replaced by the Galleon sports centre.

Top Track

Early summer 2012 saw the completion of Kilmarnock's latest sporting asset, the Ayrshire Athletics Arena. Built to international Olympics standard, it is expected to attract local, national and international events to the area.

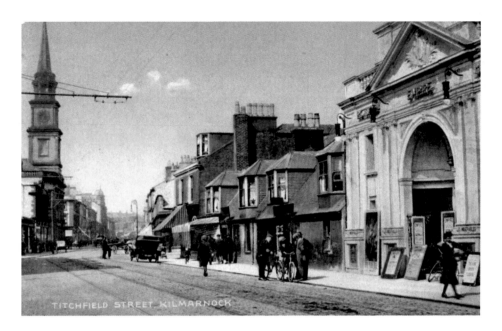

The Empire

The Empire Theatre was opened in 1913 but was always overshadowed by the King's Theatre next door. Both later became cinemas. One endearing feature of the Empire was the back row made of double seats, for those who liked a little intimacy in the cinema. The building was destroyed by fire in 1965.

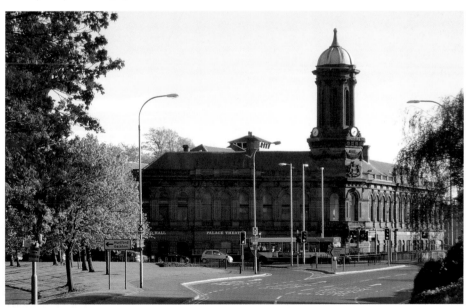

Palace Theatre

The Palace Theatre was first opened in 1903. Over the decades it has undergone various transformations, including a brief change of name. However, it is the Palace Theatre again and it continues to bring a wide variety of shows and events to both the theatre and the adjacent Grand Hall.

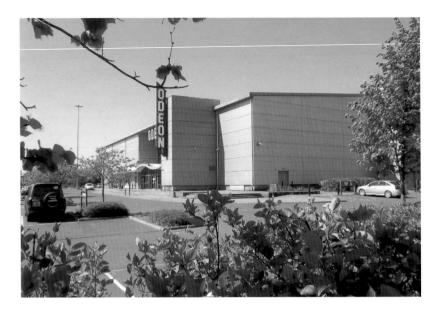

Silver Screen

At one time Kilmarnock had seven cinemas, but a decline started with the advent of television. Today the only cinema in Kilmarnock is the Odeon, which was built on land at Queen's Drive that had been used by Glenfield & Kennedy.

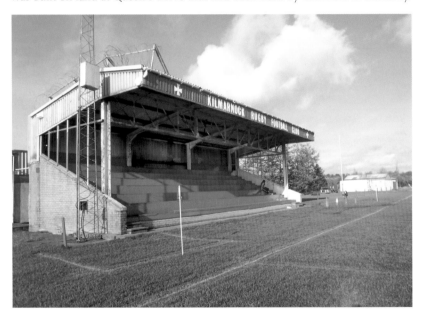

Ball Game

A new Kilmarnock sports club was founded in 1868. At first both rugby and football were played by club members. However, the club soon split allowing one group to pursue football and another to pursue rugby. While Kilmarnock Rugby Club retains the 1868 date of formation, Kilmarnock Football Club claims 1869 but still plays at Rugby Park. In the spring of 2012 the rugby club was planning to move from Queen's Drive to a new home off London Road.

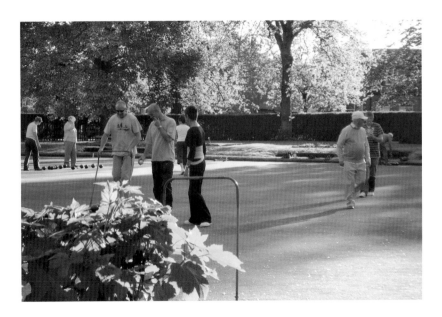

Bowled Over

There are many bowling clubs in Kilmarnock, such as Howard Park BC, pictured. The oldest club in the town is Kilmarnock Bowling Club, which was founded in 1740 with support from the town council who saw bowling as more agreeable than cock-fighting. Kilmarnock Bowling Club is the oldest continuous bowling club in Scotland.

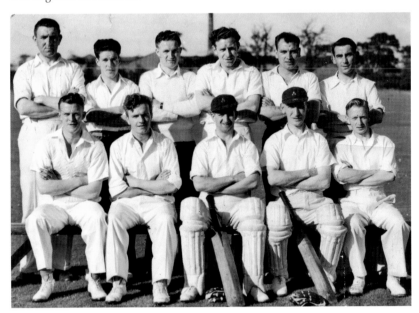

Never Stumped

In 1852 four local cricket enthusiasts met in the Commercial Inn and formed the Kilmarnock Winton Cricket Club, but today it is just Kilmarnock Cricket Club. Over the years the club has had many successes, while other local cricket clubs have come and gone such as the Saxone Cricket Club seen here in 1951.

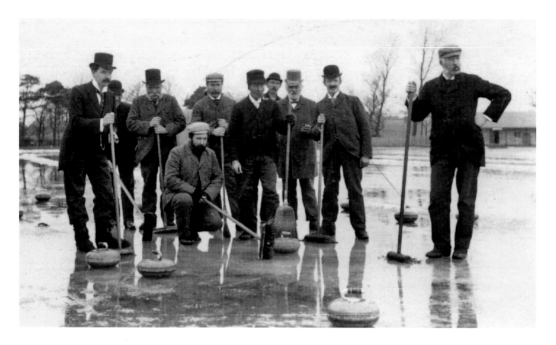

Roaring Game

The ancient game of curling is said to have been developed in Scotland. The roaring game was played in Kilmarnock as early as 1644. The winter of 1740 was a severe one. Artificial dams were created in the streets around Cross and the area was flooded so that the water would freeze and create an ice rink for curling. This allowed the game to be played for twenty-three successive days, not including Sundays, of course. With milder winters most curling today is played indoors.

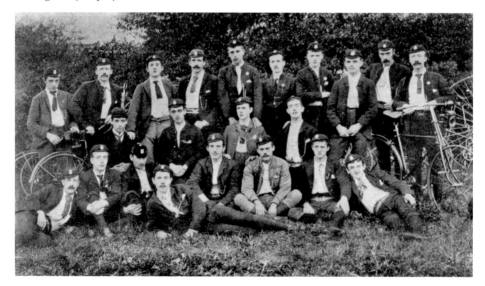

Cycling Together

The second half of the nineteenth century saw the rapid development of the bicycle, and as cycling became more popular many cycling clubs were formed. This picture from about 1890 shows members of the Kilmarnock Portland Cycling Club on one of their trips.

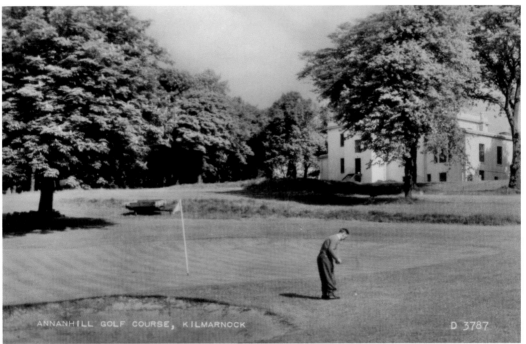

ANNANHILL GOLF COURSE, KILMARNOCK

D 3787

Golf to the Fore

Another sport which developed in Scotland is golf. Kilmarnock has two public courses: at Caprington, opened in 1909; and at Annanhill, pictured, opened in 1957. Private member clubs in the area include the world-class Rowallan Golf Course, the only course with a real nineteenth hole, which is used to settle tied matches.

A modern classic...

MONTY is following in the footsteps of legendary golfers Bobby Jones, James Braid and Old Tom Morris by using his on course skills to design a modern classic at Rowallan.

From the opening hole dog-legging right for 431 yards through trees, to the stunning Par 3 eighth sitting alongside one of two castles on the estate, this will be a testament to the Troon golfer's experience of winning on the best courses in the world.

He said: 'When I first visited Rowallan estate I got very excited about the chance to build a world class parkland course that will complement the spectacular old links courses we are so lucky to have in Ayrshire.

"Whoever laid out the estate hundreds of years ago has gifted us some of the best views in the country."

Despite the beauty of the location, though, golfers can expect a test that is second to none.

The eight times European Order of Merit champion wants this to be 18 holes where good course management is more important than brute strength. When it opens for play next year even the best players will have to bring their 'A game' to tackle the natural rolling contours of Rowallan Castle, according to Monty.

At nearly 6900 yards from the championship tees to a shade over 6300 from the regular 'boxes' it will provide a stern but fair test for golfers of all abilities.

His first UK course will complement an impressive portfolio that Carton House near Dublin Montgomerie Course at Emirates Golf Club in Dubai.

Taking inspiration from Melbourne, Monty has designed traps that eat into greens all but the most accurate of shots even though this is a parkland links style pot bunkers will heavily. One thing is certain, have to be precise or the sand see plenty of action at Rowall

Colin Montgomerie's Carton House near Dublin (above) is regarded as one of the finest new courses in Europe. It provides a flavour of how Rowallan (right) will look.

Rowallan Castle's blend of ancient and modern will make it the perfect place to escape from the stresses and strains of the 21st century

A VISIT to Rowallan will be a step back into history with all the trappings of modern five star hotel luxury.

Under the guidance of award-winning hotelier Gordon Campbell Grey guests will enjoy the ultimate in quality with state of the art rooms and suites fitted with the latest audio-visual systems.

It goes without saying that at Rowallan, whether in t or the club house, will com the Scots baronial setting, L finest Scottish ingredients, which will be grown in the organic kitchen garden.

And to make this the refuge from the stress and

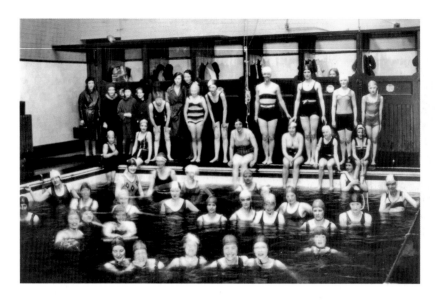

Making a Splash

Kilmarnock Amateur Swimming Club was formed by enthusiastic swimmers in 1902. At that time they had to use ponds in local rivers, but before the end of the decade they had the use of the pool in the new technical school, later part of Kilmarnock Academy. That pool is seen here in the 1930s. Later the club used the town's swimming pool. The club has produced several swimmers who won international recognition and today still has a strong membership.

Something Fishy

Anglers can enjoy their sport with the certainty that there are fish in the area they attend. Fisheries such as the one at Craufurdland, pictured, enjoy a large following.

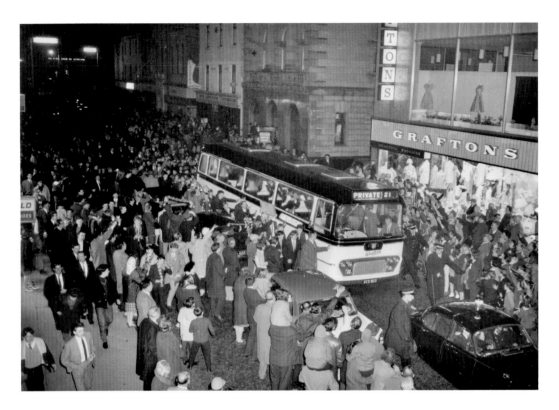

A Hero's Welcome

Kilmarnock Football Club was founded in 1869 and is one of the oldest clubs in Scotland. The picture shows the team returning to Kilmarnock after winning the league in 1965. Today Kilmarnock is the only Ayrshire team in the Scottish Premier League.

Dean Park

The land used to create the Dean Park was given to the people of the town by Lord Howard de Walden in 1907. It soon became a favourite place for sports as well as for walks in the gardens. Today it is adjacent to the Dean Country Park, which has been developed since the 1970s and has Dean Castle as the central feature.

Howard Park

Part of Howard Park was previously Wards Park and Barbadoes Green, both originally part of the grounds of Kilmarnock House. The park was given to the town by Lord Howard de Walden and opened in 1894. There are various features in the park which reflect the town's history.

Kay Park

Kay Park was developed at Clerk's Holm and was opened in 1879 with money from Alexander Kay, a Kilmarnock man who made a fortune in insurance. The park contains the Burns Monument Centre, home to the district registrar and also to the town's local history library and family history research facilities. The centre is unique in Scotland in bringing all these features together and was opened by Scotland's First Minister in 2009. This picture of the park was taken in 1913.

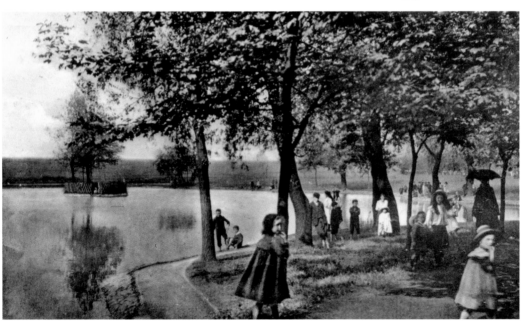

The Wider World

For 300 years Scots have been told their best option is to leave their native Scotland for other lands. Most towns and villages had an emigration club. In the nineteenth-century people were encouraged to save up to help them start a new life in another country. This deliberate policy, imposed from outside Scotland, has drained our country of our finest talent. But other countries have benefited. That's why the United States, Canada, Australia, New Zealand and many other countries have a strong Scottish influence. Indeed, the American Declaration of Independence was strongly influenced by Scotland's Declaration of Arbroath of 1320.

This chapter looks at some of those who have had an impact on the wider world. They include people like Sandy Allan (1780–1854) who founded the Allan Shipping Line which pioneered scheduled passenger services across the Atlantic and was the parent company of the Canadian Pacific Railway.

Other Kilmarnock folk include the following:

John Burtt (1789–1866) went to the USA and became editor of an influential religious paper. Robert Dunsmuir (1825–89) settled in Vancouver Island, Canada. While there, he amassed a fortune developing the rich coal deposits there as well as a railway network. Andrew Fisher (1852–1928) became the first Labour Prime Minister of Australia. William Muir (1819–1905) spent most of his life in India. He was eventually made the Lieutenant Governor of the North West Provinces. Sir Hugh Muir Nelson (1835–1906), immigrated to New South Wales and later became Lieutenant Governor of Queensland. John Boyd Orr (1880–1971) became the first director general of the United Nations Food and Agricultural Organisation. William Reid (1822–88) founded Reid's Palace Hotel on the island of Madeira. It is still regarded as one of the world's top hotels. James Stevenson (1873–1926) restructured the rubber industry in Ceylon (now Sri Lanka) and Malaya (now Malasia). Sir George Fowlds (1860–1934) became a prominent politician in New Zealand and a leading educational reformer.

Some very talented people did stay, however, and have had a significant impact on life in Scotland and on the wider world.

'Born 1820 ——
Still going strong'

Goes everywhere

Single Scotch

In every market where alcohol is a legal product you can buy Johnnie Walker whisky. The name is known across the world, and yet it was not Johnnie Walker but his son and grandson who turned the product into one of the world's first global brands. In New Zealand the Kilmarnock Glacier is said to have taken its name from the name of the town found on bottles of Johnnie Walker whisky.

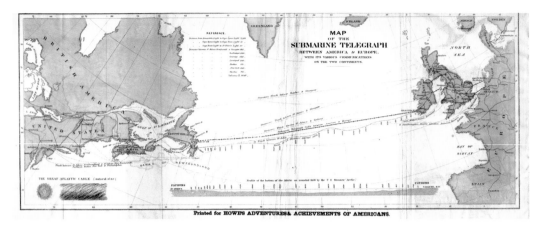

Printed for HOWE'S ADVENTURES & ACHIEVEMENTS OF AMERICANS.

Cable Guy
Kilmarnock engineer Andrew Barclay is well known for engineering products, particularly locomotives, but he also conducted important experiments for the Atlantic Cable project particularly in relation to the insulation of the cable.

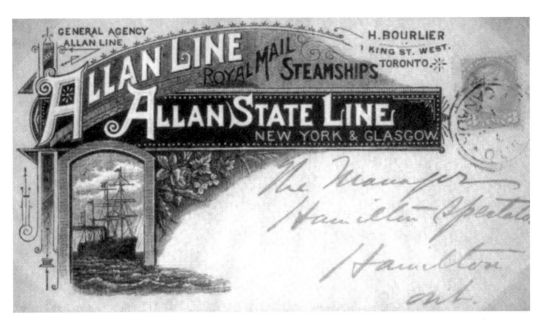

All at Sea
Captain Sandy Allan was a shipping magnate who was born at Old Rome, on the edge of Kilmarnock in 1780. He founded the Allan State Line which grew from being a one-man business to being the biggest privately owned and the seventh-largest shipping line in the world. Sandy Allan pioneered scheduled passenger services across the Atlantic. The shipping group was also the parent company of the Canadian Pacific Railway.

London Bound
James Shaw was born at Riccarton in 1764. In 1781 he left for America but returned a few years later. Then he headed for London where he quickly rose through the ranks of society. He became an MP and Lord Mayor of the city. He was Lord Mayor of London at the time of Nelson's funeral and joined the King in leading the national mourning. His Kilmarnock statue is in London Road.

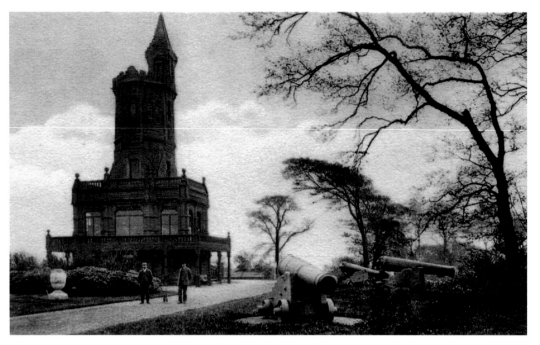

Robert Burns

Scotland's most influential poet was Robert Burns and today his birthday is celebrated worldwide each January 25. Many countries have a statue or a monument to him and Kilmarnock has two. Pictured is the original Kilmarnock Burns Monument guarded, for some reason, by cannons, and the statue to Burns on the Embankment in London.

Penicillin Man

The picture shows Lochfield Farm, near Darvel, the birthplace of Alexander Fleming. He attended the local primary school and Kilmarnock Academy. His dedicated research, his thoroughness and his desire to get all the answers led to the discovery of penicillin, which has saved millions of lives. He shared a Nobel Prize for medicine for his pioneering work on isolating and identifying penicillin. There is a monument to Fleming in Darvel and his portrait has appeared on Scottish banknotes and the stamps of many countries.

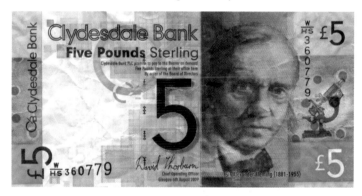

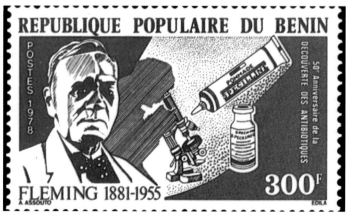

Pit to Premier

Andrew Fisher was born at Crosshouse in 1862 and worked as a miner when he was still a child. As he grew up he became active in politics and the trade union movement. After going to Australia he entered politics there and quickly rose through the ranks of the Labour movement. In 1908 he became the first Labour Prime Minister of Australia. A memorial garden was dedicated to him in his native village in 1979.

Man of Education

George Fowlds was born at Greystoneknowe, near Waterside, Fenwick, and in his early years was educated in the village school. He was apprenticed to a tailor and later worked in a wholesale warehouse in Glasgow. In 1882 he went to Auckland, New Zealand, where he opened a clothing shop. This was successful enough to allow him to follow a political career. He was a Member of the House of Representatives and followed a keen interest in education and social reform. He was Minister for Education and Public Health from 1906 to 1911. His archive of about 22,000 letters went to the University of Auckland.

City Park

Robert Jameson was born in Kilmarnock and fought in the Crimean War. In 1856 he went to Durban where he started a jam-making business. He advocated planting shade trees in the streets of the city. In 1895 he became Mayor of Durban and was elected to the Natal Legislative Council. He was also instrumental in developing the Durban Botanic Gardens, which are now world-famous. Jameson Park in the city was named in his honour.

Business Genius

James Stevenson was born in Kilmarnock and began his career with the Kilmarnock whisky firm Johnnie Walker. During the First World War he was seconded to government service where his business flare was invaluable. He later restructured the rubber industry in Ceylon – now Sri Lanka – and Malaya – now Malaysia. He was the general manager of the Empire Exhibition at Wembley in 1924 and 1925 and after the exhibition was instrumental in ensuring that the iconic Wembley towers were retained.

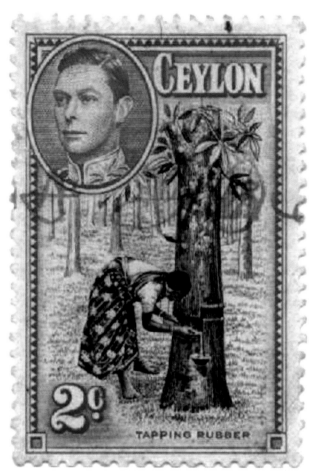

Map Maker

James McKerrow was born in Kilmarnock and went to New Zealand in 1859. He became a surveyor and was eventually the Surveyor General for the whole country. He named many hills and rivers after places from his native Ayrshire. He was also Chief Commissioner of Railways and a keen amateur astronomer and scientist. The McKerrow Glacier is named after him.

Peace

John Boyd Orr was born in Kilmaurs and was a student at Kilmarnock Academy. He became an expert in nutrition and during the Second World War the nation's food rationing was devised largely on the basis of his research. After the war he became the head of the United Nations Food and Agricultural Organisation and helped to restore the world's food production. For that he was awarded the Nobel Prize for Peace.

Hotel Dream

William Reid left the Kilmarnock area to live in Madeira in the belief that the better climate would improve his health. He made his fortune dealing in wines and planned the Reid's Palace Hotel on the island as one of the world's greatest hotels. He died in 1888 not long before the hotel was completed, but it did achieve the status he hoped for.

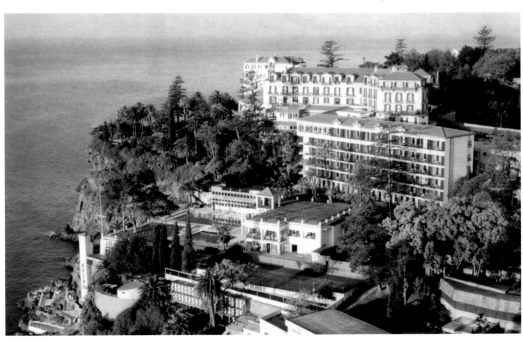

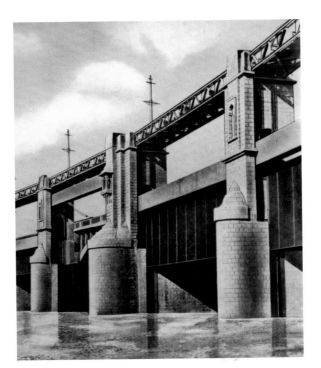

Dam It

Kilmarnock engineers Glenfield & Kennedy took their skills across the world. This is a photograph of the Cauvery-Mettur Sluice Gates, installed by The Glen at the Cauvery-Mettur Dam in India. Glenfield built and installed many water and sewage systems across the world, particularly in countries of the Commonwealth.

Furniture on Set

In 1843 William Sloane from Kilmarnock immigrated to New York and set up a shop dealing with imported carpets, presumably mostly from Kilmarnock. William's brother, John, joined him a few years later. Together they built a reputation of being the best place in New York for quality furniture. They were soon offering a home decorating service and with the advent of movies, moved into making movie sets. The business traded until 1985.

All Together Now
Kilmarnock has been working with twin towns since our first formal town twinning agreements were reached in 1974 with Kulmbach in Germany and Ales in France. This statue at Foregate Square commemorates town twinning.

And Finally
If you have any doubts about where Kilmarnock is, look at this postmark. Kilmarnock, Jamaica? There are several Kilmarnocks around the world; the main ones are in Virginia, USA; Ontario, Canada; South Africa, and several minor ones in other places ... and, of course, there is one in Scotland.